Wonders *of* Abu Simbel

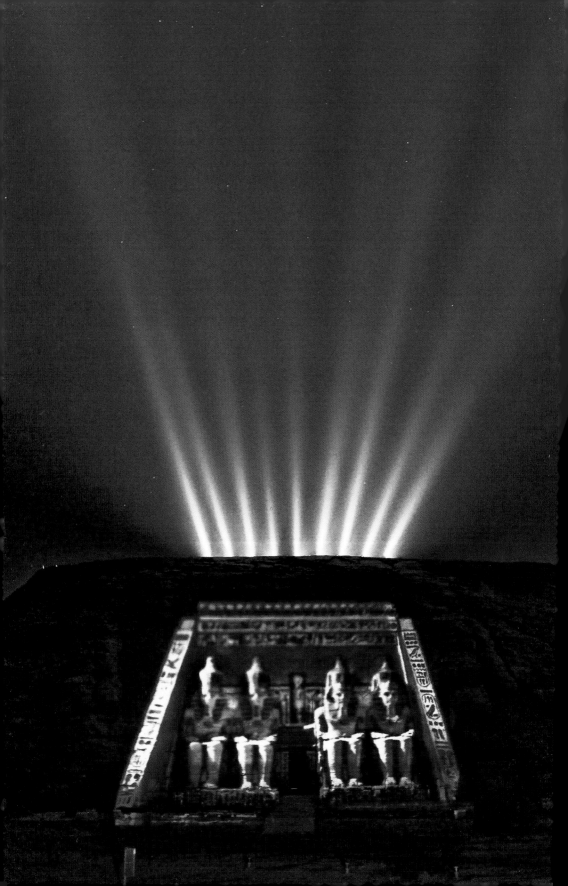

Wonders *of* Abu Simbel

The Sound and Light of Nubia

Introduced by

Zahi Hawass

Misr Company for Sound, Light, & Cinema—Cairo
Distributed by the American University in Cairo Press

Photographs by Emad Allam, pages: ii, 2, 4, 26–33, 46–72, 89
Photographs by Sherif Sonbol, pages: 37–45

Dar el Kutub No. 23206/09
ISBN 978 977 17 8028 1

Dar el Kutub Cataloging-in-Publication Data

Hawass, Zahi
 Wonders of Abu Simbel: The Sound and Light of Nubia / Introduced by Zahi Hawass.
 First edition—Cairo: The American University in Cairo Press, 2010
 90 p. cm.
 ISBN 978 977 17 8028 1
 1. Theater–sound effects 2. Great Temple (Abu Simble, Egypt)
 I. Hawass, Zahi, 1947 (intro)
 792.024

1 2 3 4 5 6 7 8 15 14 13 12 11 10

Distributed by the American University in Cairo Press
113 Sharia Kasr el Aini, Cairo, Egypt
420 Fifth Avenue, New York, NY 10018
www.aucpress.com

Designed by Jonathan Boylan
Printed in Egypt

Contents

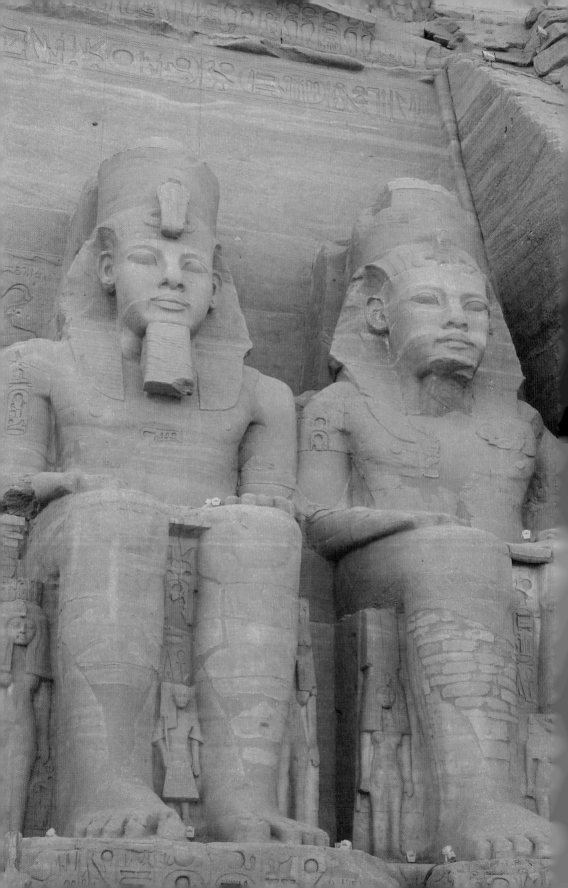

Preface

The temples of Abu Simbel are a work of fine architecture and an icon of human civilization. Through an international team effort, they were moved from their original location to a neighboring artificial hill that shares the same coordinates and specifications. The relocation was undertaken by several countries—under the umbrella of the UNESCO and the Egyptian Ministry of Culture—to save the temples from being submerged under Lake Nasser after the construction of the Aswan High Dam.

In 2000, the Misr Company for Sound, Light, and Cinema commenced the Sound and Light Show project at the Abu Simbel temple area. To celebrate this occasion, *Abu Simbel—Temples of the Shining Sun* was published in the same year, and included a preface by Minister of Culture Farouk Hosny, and contributions by Secretary General of the Supreme Council of Antiquities Zahi Hawass. Today, in 2010, we introduce this new book on the occasion of the tenth anniversary of the inauguration of the sound and light show project.

Despite the limiting of guided tours of the Abu Simbel temples to morning hours, visitors now have the chance to watch a Sound and Light Show in the evening to avoid the heat of the day. During the show, they hear about Ramesses II and the accomplishments of his reign, such as the first attested peace treaty in history. The narration, which has been drafted by

of the four colossi of
esses II, Great Temple

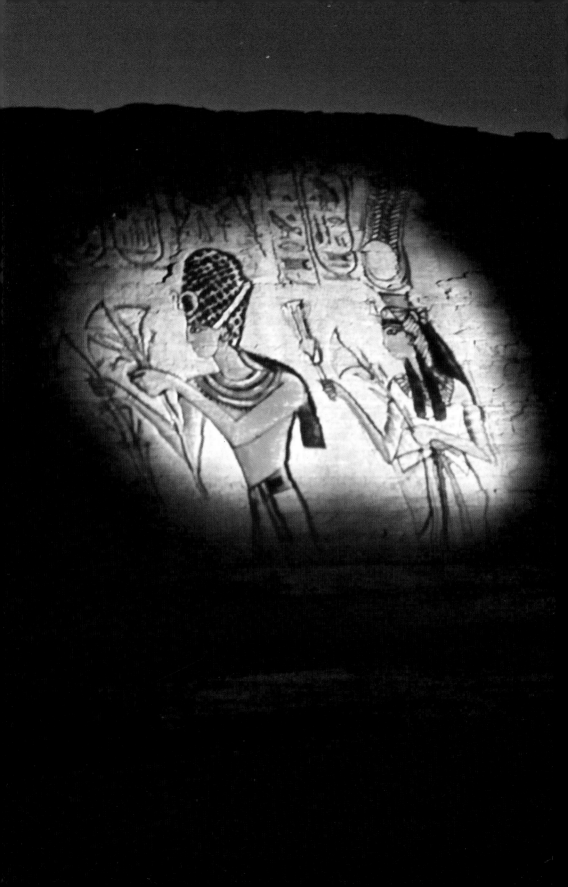

experts from the Supreme Council of Antiquities, is accompanied by sound effects and giant image projection.

Not only do viewers get the sense that they are reliving these historical scenes, but they also have an opportunity to see what the Ramesses and Nefertari temple walls looked like in their original colors. Special effects also allow visitors to watch the sun's rays striking the statues of Ramesses twice a year, deep in the heart of the temple. The show ends in what feels like a violent earthquake—the temple walls shake, heavy rain pours down, sounds of thunder are heard, and images of lightning are seen, ending in the collapse of the top of one of the statues of Ramesses. Darkness and silence fall, when the temples and the top of the statues finally reappear.

We are happy to announce that the project has greatly improved tourism and sustained social development in Abu Simbel and Nubia. Until the Sound and Light Show, the city was lacking in many evening activities. The show boosted the city's economy through the increasing number of visitors frequenting hotels, stores, restaurants, and cafes. Furthermore, boat rides and local and international flights increased. The state government contributed to this boom by spending on local services and infrastructure, which helped create job opportunities and improve commercial activity.

On the occasion of the tenth anniversary of the inauguration of the Sound and Light Show project at Abu Simbel, we would like to thank the key stakeholders, especially Mr. Mohamed Shafiq as the lead in developing and implementing the project. He headed a team of engineers and technicians who worked to overcome many constraints, and worked closely with travel companies and state officials for the successful marketing and promotion of the project. We follow the same approach for sustainable success and further development.

Essam Abdel Hadi
Chairman and Managing Director
Misr Company for Sound, Light, and Cinema

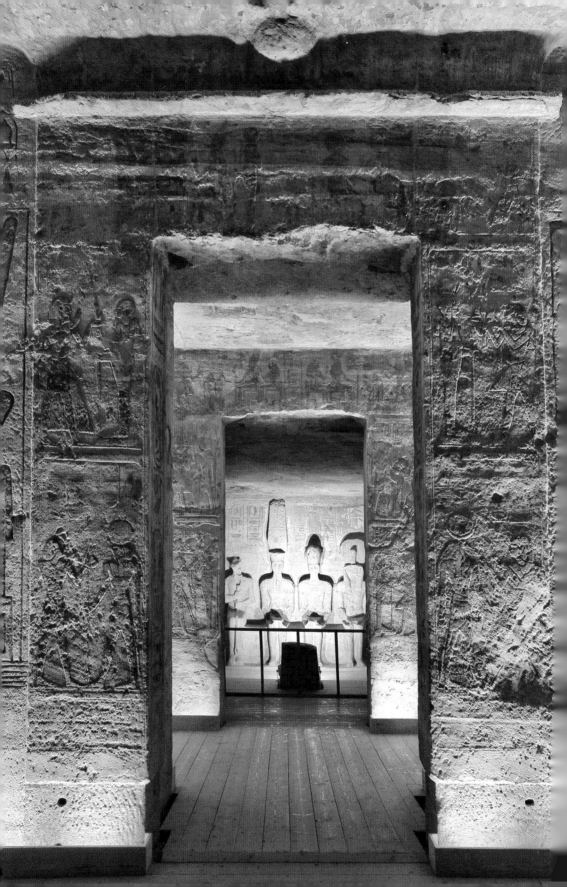

The Marvels of Abu Simbel

Zahi Hawass

The temples of Abu Simbel lie about 280 km (170 miles) south of Aswan, in a region known to the ancients as Nubia. This geographical term first appears in about 25 BC in the writings of the Greek historian and geographer Strabo, who used it to refer to the area of African desert bisected by the Nile that extends from the First Cataract at Aswan in the north to the Fourth Cataract in the south. The area was traditionally divided into two distinct geographical regions, each with its own unique climate and topography. Lower Nubia, now largely under Egyptian control, includes the area between the First and Second cataract, while Upper Nubia, which belongs to Sudan, extends from the Second Cataract to the Fourth Cataract.

By 3050 BC, Egyptian expeditions had traveled south at least as far as the Second Cataract. At this time, the deserts flanking the Nile were wetter than they are now, and significantly large populations occupied both Upper and Lower Nubia. By 2500, at the height of the Egyptian Old Kingdom, the Sahara had dried up, and Lower Nubia was occupied only by sparse nomadic bands. Upper Nubia, which had a larger amount of fertile soil, continued to develop its own distinctive and highly evolved civilization.

From the earliest times, Nubia was a bridge between the southern civilizations in the heart of Africa and the Egyptian and Mediterranean cultures to the north. As a consequence, Nubian culture borrowed features from the

nner sanctuary
e Great Temple

southern African cultures on the one side and the cultures of Egypt, Greece, and Rome on the other. However, the strongest influence came from Egypt because of its close proximity, the similarity of its topography, and the military and political contacts that were established at least as early as the third millennium BC.

The waxing and waning of Egypt's strength can be traced through its relations with Nubia. When strong kings ruled a united land, Egyptian influence extended into Nubia; when Egypt was weak, its southern border stopped at Aswan.

Nubia was a very important source of trade goods such as ivory, wood, leather, incense, and exotic animals such as monkeys and giraffes. Gold, granite, and diorite were also mined in Nubian quarries. In fact, gold was so plentiful in Nubia that the name comes from the word for gold in ancient Egyptian. The importance of gold to the Egyptian is underlined in a letter from the king of the Mittani to King Amenhotep III, which says, "send me gold in your country ... gold is like dust."

During the Old Kingdom, Egypt traded peacefully with the inhabitants of Upper Nubia, which they called Yam. In order to protect their trade routes from the nomadic bands who lived in Wawat, or Lower Nubia, the Egyptians established a series of settlements in the area. These were abandoned in about 2420 BC, when the centralized Egyptian government lost power and the country splintered into the competing dynasties of the First Intermediate Period.

By the Middle Kingdom, Upper Nubia was ruled by the powerful kingdom of Kush, which represented a military threat to Egypt. The kings of the Twelfth Dynasty responded by building a series of impressive fortresses that secured the region from the First to the Second Cataract. Kush and Egypt continued to trade, but in an atmosphere more of armed truce, with Egypt maintaining Lower Nubia as a buffer zone. Campaigns were frequently mounted into the area to subdue rebellious natives and to control the flow of trade from the south, and the Egyptians did their best to Egyptianize the Lower Nubians and enforce their loyalty to Egypt.

In about 1650 BC, as Egypt once again fell into internal disarray, the rulers of Kush invaded Lower Nubia and took over the Egyptian forts. During the Second Intermediate Period, the Egyptians also lost control of the north of their own country to the Hyksos, foreigners from the Levant who ruled from Avaris (near the future site of Per Ramesses) in the Delta.

In one of the lowest points of pharaonic history, the Hyksos in the north and the Kushites in the south formed an alliance against the native Egyptians who were ruling their remaining territory from Thebes. Apophis, the Hyksos king, sent a messenger to the ruler of Kush inviting him to join forces and attack the Egyptian king. Fortunately, the messenger was caught by the Egyptians at the border of the Bahriya oasis, and disaster was averted.

After the Egyptians expelled the Hyksos from Egypt, they made good use of the lessons they had learned. Between about 1570 and 1500 BC, the Egyptians reestablished control over the Lower Nubian fortresses and extended their empire into Upper Nubia, all the way to Napata, just north of the Fourth Cataract. Until the end of the New Kingdom, ca. 1085 BC, both Lower and Upper Nubia were colonial possessions of Egypt. The native rulers were replaced with Egyptian or Egyptianized governors who answered to the Egyptian king at Thebes. Nubian soldiers and bowmen from the Eastern Desert served in the Egyptian army, and even fought with the Egyptian kings on campaigns into Syria and Palestine. There were occasional rebellions, but these seem to have been put down quickly, and Egyptian control over the area was maintained.

A number of New Kingdom pharaohs built chapels and temples in Nubia, establishing them as religious centers where Egyptian gods and kings were worshiped. These temples played an important role in Egyptianizing the people of Nubia, and guaranteeing their loyalty to the pharaoh as the embodiment of god on earth. The temples of Ramesses II at Abu Simbel represent the most magnificent of these Nubian temples, a living testament to the power and wealth of the Egyptian empire.

After the fall of the Egyptian New Kingdom, native rulers reasserted control over Nubia. In fact, the kings of the Napatan culture, centered around the Fourth Cataract, grew so strong that they invaded Egypt and ruled it

for a short time (ca 751-656 BC) as the Twenty-fifth Dynasty. Christianity entered Nubia from the north and reigned supreme until Islam was introduced and rapidly became the dominant religion among Nubians.

Ancient Nubia became known to Western civilization during the nineteenth century. The first important western visitor to Nubia was John Lewis Burckhardt, who went by camel from Aswan to Dongola in 1813. Many others followed in his footsteps: Jean Nicolas Huyot, François-Chrêtien Gau, Karl Richard Lepsius, James Breasted, and Wallis Budge, among others. Each of them published valuable descriptions of the monuments they saw during their journeys through Nubia and Egypt.

Abu Simbel was first noted in 1813 by Burckhardt, who suspected that a vast temple lay beneath the desert sands. The first European to clear sand from the temples at Abu Simbel was circus strongman Giovanni Belzoni, who uncovered the entrance to the Great Temple in 1817.

In 1907, George Reisner started the first important scientific survey and excavation of Nubia. This survey was continued by C. M. Firth from 1908 to 1911, and resulted in fifteen illustrated volumes on the Nubian temples and a detailed description of the monuments and cemeteries in the area. Many other survey and excavation projects were carried out in the area until 1959, when it was announced that a high dam would be built at Aswan.

The monuments of Nubia were protected for thousands of years by the sand that buried them and shielded them from the ravages of wind and time. Their remote locations kept them from being destroyed by the spread of modern civilization, although many of these temples were converted to churches after the introduction of Christianity.

The temples and churches of Lower Nubia were first threatened in 1902, when the Egyptian government built a dam at Aswan that created a reservoir of water to the south. This dam was rebuilt in 1912 and 1936, in both cases resulting in further water damage to monuments within the reach of the rising reservoir waters. At that time, the Egyptian Antiquities Organization began restoration and conservation projects to confront this threat.

In the 1950s, the Egyptian government decided to replace the current small dam at Aswan with a much larger dam. This was to be constructed of rock, and was to measure 3,600 m (12,000 ft) long, 40 m (130 ft) wide, 180 m (600 ft) at its base, and rise to a height of 104 m (340 ft) above sea level. Floods to a height of 182 m (597 ft) can be held back by the dam. The artificial lake created by the dam, Lake Nasser, extends 500 km (315 miles) in length, stretching south beyond the Second Cataract, and up to 25 km (16 miles) in width.

The construction of the Aswan High Dam was begun in 1960 and finished in 1964, and represents one of Egypt's most successful national projects. By means of this dam, the waters that once flooded the land every year can now be controlled and used efficiently. No longer a victim of the irregular and unpredictable floods that produced the years of feast and famine that are woven into the fabric of Egyptian history, Egypt now enjoys control over its own fate. The High Dam also provides Egypt with electrical power for the villages that line the Nile, thereby helping to raise the cultural and educational level of the entire country.

There has been a great deal of concern in the world media about the effect of the High Dam on the monuments of Egypt. The salinity of the water table that underlies the bedrock of the Nile Valley has risen dramatically over the course of the past fifty years, causing salt to leach into the walls of the ancient monuments and eat away at their surfaces. It was long believed that the High Dam was causing this terrible problem; however, recent scientific analysis has shown that the deterioration of the monuments can be traced to salt-filled runoff from the many villages that still lack modern sewer systems.

Despite the many potential benefits of the High Dam, Egypt faced the huge problem of saving the archaeological sites that would disappear under the waters of the expanded reservoir. These monuments included not only major temples such as those of Abu Simbel, but also chapels and settlement remains, stelae, inscriptions, and as yet undiscovered sites. The Egyptian government recognized that in order to be effective and timely, a salvage campaign to rescue the monuments needed international support, and sought the help of UNESCO.

This was the first such request UNESCO had received since its inception in 1954. The Executive Council welcomed the request of the Egyptian government when it met in July of 1959. The council agreed that the monuments of Lower Nubia represented a unique part of the ancient heritage of humankind. The extreme antiquity of the sites and their location in an isolated and sparsely inhabited area of the world made them a perfect focus for an international relief effort.

On March 8, 1960, a historic event, attended by many important international figures, took place in Paris. Vittorino Veronese, the General Secretary of UNESCO from 1958 to 1961, and his successor, Rene Maheu, president of UNESCO from 1961 to 1974, called on governments, international organizations, and any group concerned with our international heritage to provide help in the form of funds or technical assistance. The response was overwhelming: committees and researchers from over twenty countries worked together for twenty years on the highly successful campaign launched by this event.

A thorough record of the monuments of Lower Nubia was made in a very short period of time and many salvage excavations were carried out. The single most impressive accomplishment of the committee was the moving of the Abu Simbel temples from their location directly in the path of Lake Nasser to a higher location out of reach of the water. Many countries, including the United States, France, and Germany, and individuals such as Madame Lila-Atcheson Wallace, owner of *Reader's Digest* magazine, contributed generously in both time and money toward this operation, which took five years and cost forty-two million dollars. The most remarkable contribution came from children all over the world, who sent their allowance money to help with the salvage effort. The world media gave the campaign enormous attention and support, and UNESCO sent out scholars to lecture on the importance of the campaign. Films, books, posters, and photographs about the temples were widely published.

The successful Nubian campaign prompted other countries to petition UNESCO to help save their own monuments. Campaigns were mounted to help preserve the canal city of Venice in Italy, the Acropolis of Athens

in Greece, the ancient city of Mohenjodaro in Pakistan, Barabudur in Indonesia, and Fez in Morocco.

UNESCO and Egypt did a marvelous job of acquainting the world with the problem of the Nubian monuments and of inspiring people of all ages and backgrounds to help. Men, women, and children all responded with enthusiasm and support, and their combined contributions helped to save the beautiful temples of Abu Simbel for posterity. The most spectacular of the threatened Nubian monuments were the two temples at Abu Simbel, which lay directly in the path of the new reservoir.

In 1980 the Egypt Sound and Light Company was designated by the Egyptian government for sound and light shows at its monuments. Even before that time, the company had produced two shows for ancient sites in Egypt, the first at the Giza Pyramids, which began sound and light shows in 1961, and the second at Karnak in Luxor, beginning in 1972. After the company established a third project at Philae in Aswan, it began to think of a fourth sound and light project at the two temples of Ramesses II and Nefertari at Abu Simbel.

The Egypt Sound and Light Company made all the scientific, engineering, technical, and visibility studies necessary, but the project never got off the ground because the focus was then on upgrading the sound and light projects at the Pyramids and Karnak with new techniques.

In 1999 the company embarked on its Abu Simbel project because the two temples there are renowned, attracting visitors from all over the world. Mr. Mohamed Safiq, head of the company, supervised this project and used the most sophisticated lighting and sound technology. In addition, it was decided that the project should not clash but rather coexist with the monuments and their surroundings. The company cooperated with the Ministry of Culture, the Supreme Council of Antiquities, and the Receiving Company for Housing, Tourism, and Cinema in the making of this project.

The aims of this new sound and light project are:

- To open a new tourist venture in the southern part of Egypt; this sound and light program will be a new technological attraction for both Egyptians and foreign tourists, and it will bring employment and knowledge to the

area. It coincides with the Egyptian government's development of new areas of irrigation and settlement in nearby Toshka.

- To increase the number of tourist nights on the site during summer and winter. This, in turn, will increase tourist activities, the development of hotels, and reestablish Nubian crafts in the area.
- To use the site to a greater capacity: many more international and local companies will put Abu Simbel on their tourist itinerary, knowing that there are nighttime activities available. This, in turn, will increase the social and economic importance of the site and of Egypt in general.
- To reaffirm the importance of the development of the town of Abu Simbel. The airport was built to receive private flights and flights in the evening, and the show will increase flight bookings.
- To inaugurate the newly paved and repaired road between Aswan and Abu Simbel.
- To develop the area further and to create more jobs for the local people.

Several steps were taken to ensure favorable development of the project. A scientific committee, composed of the late Dr. Gamal Moukhtar, Dr. Gaballa A. Gaballa, and the author, was appointed to write the script.

The company brought in experts to translate the text into eight languages (Arabic, English, French, German, Italian, Japanese, Russian, and Spanish) and record the show's script in each language. As a result, any person watching the show can simultaneously hear his/her own language via headphones. The same music will be heard by the entire audience.

The show explains the history of Ramesses II, his triumphant victories, his lovely wife Nefertari, and the story of the two temples. The viewer sees the façade of the two temples and the huge statues in the same colors that they were in ancient times. For the first time, visitors are able to witness the sun's rays entering the temples, which without technological apparatus happens only twice a year.

The show explains the details of the inscriptions of the two temples, which are projected outside the temple for all to see. The viewer will then see scenes of the salvage of the two temples. The show next explains the life of Ramesses II. All the scenes will be images of actual reliefs from

inside the temple. I believe this is my most important idea, because in the future this show could entice visitors as an alternative to physically entering the tombs and contributing to their destruction.

The company's engineers used the most sophisticated techniques for sound; in fact, some were designed especially for this project. Forty actors and actresses were used to record the show in eight languages with experts on music and sound producing the symphonic accompaniment. The engineers also used state-of-the-art lighting technology to produce effects where light appears to be coming from behind and above the temples. The entire show is controlled and run by a computer. The seats were designed for an audience of four hundred. They are located on the northeastern side of the temple, but are not visible at a distance, and so the panorama of the temples is not affected. The equipment is hidden in wooden boxes that can be used during the day as seats for visitors to the temple.

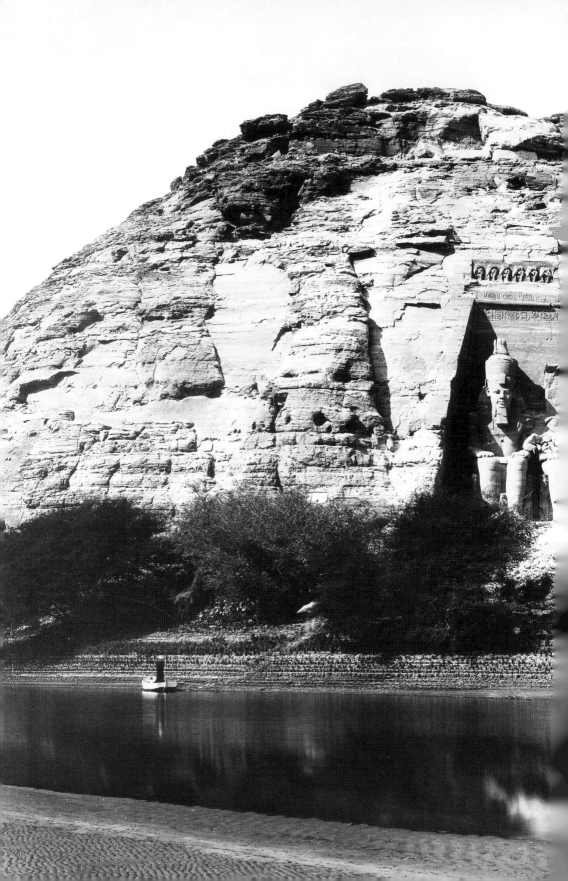

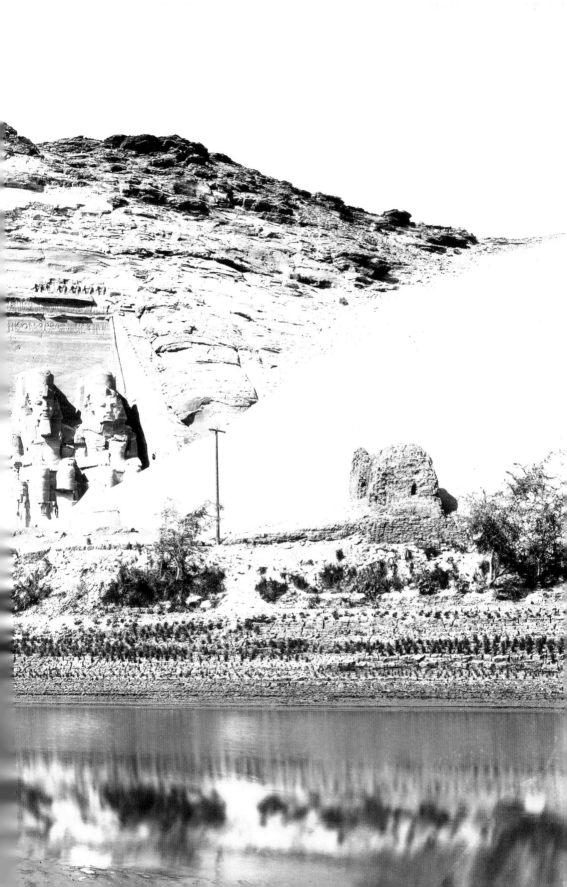

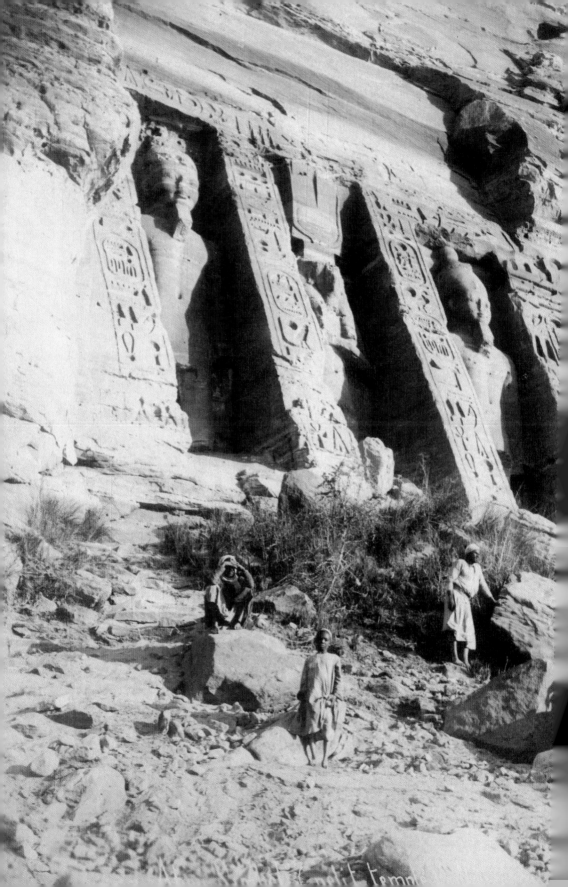

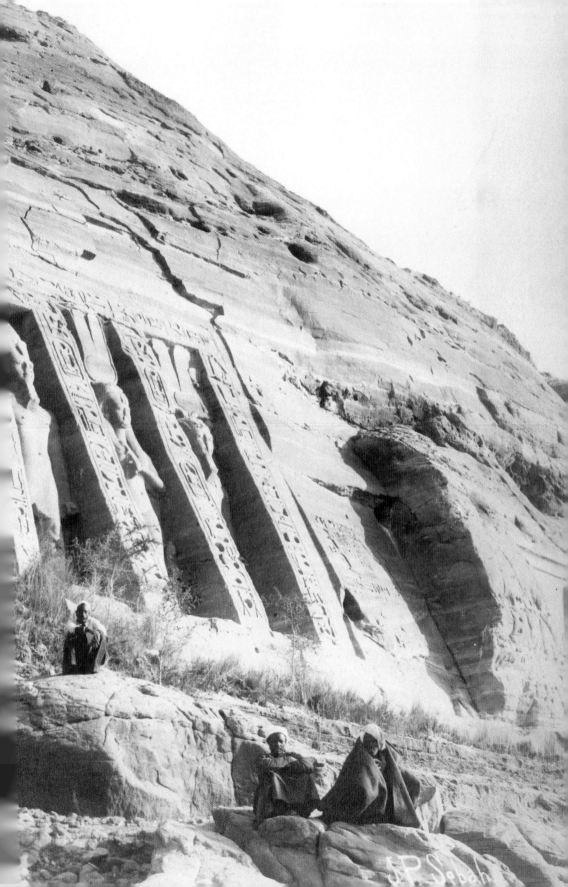

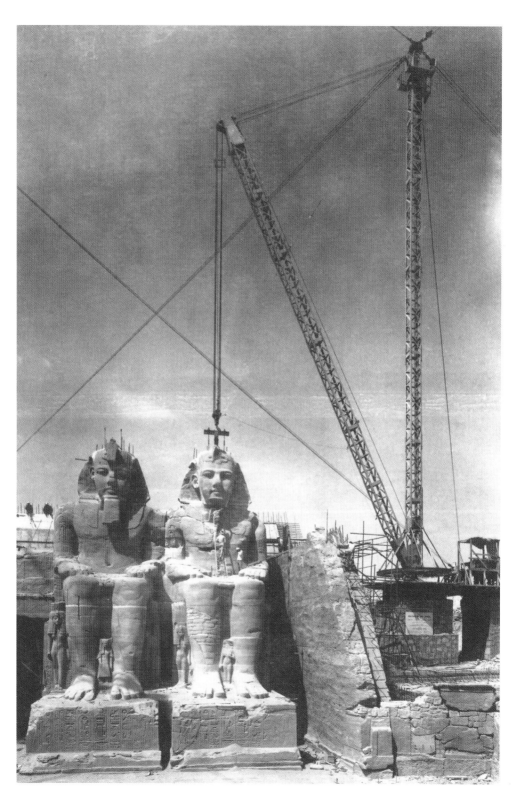

Previous pages: The temples of Abu Simbel as they appeared in the late nineteenth century

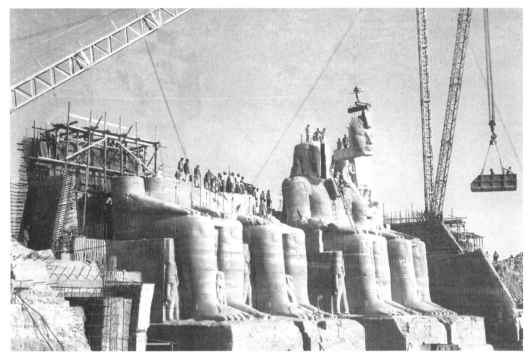

Above and opposite: The reconstruction of the Great Temple

Below: Inside the artificial hill

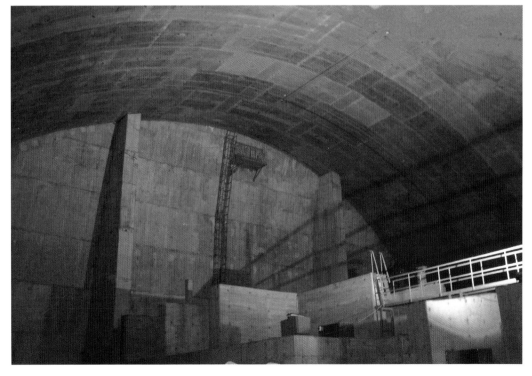

Following pages: The façade of the Great Temple

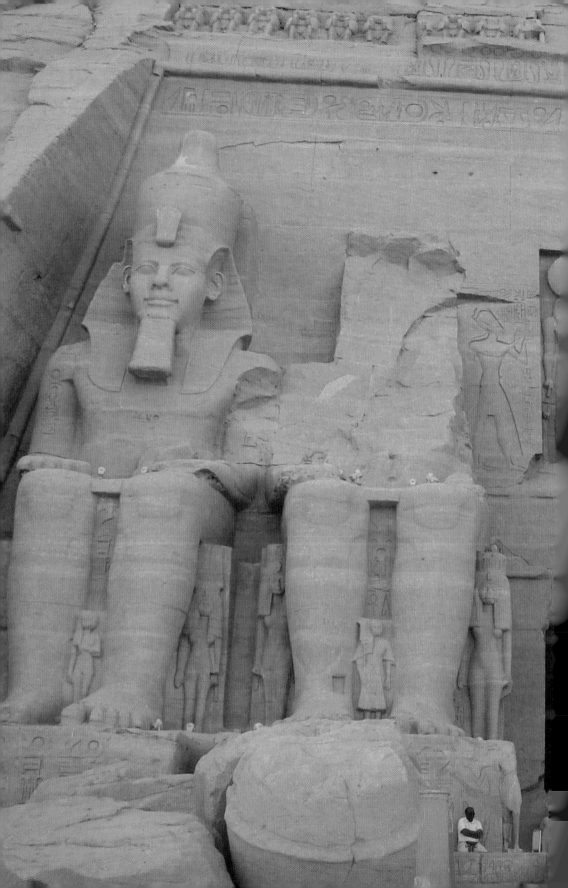

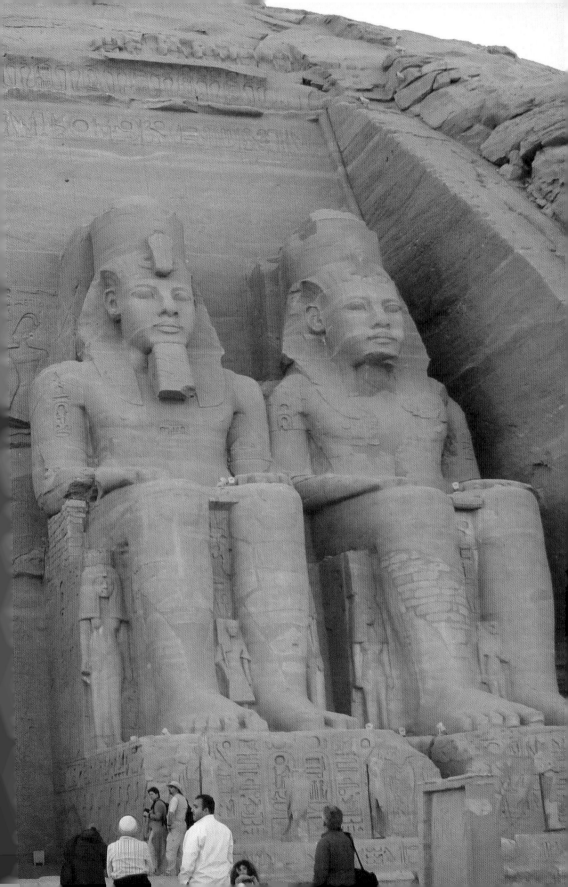

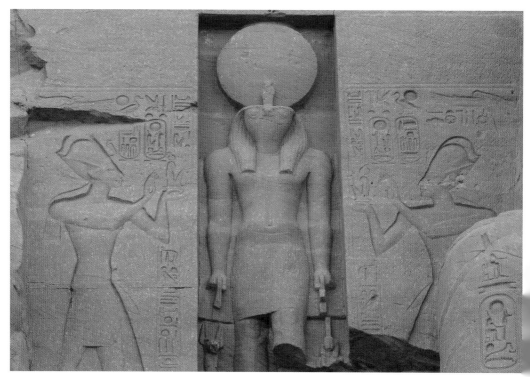

The falcon god Horus on the façade of the Great Temple

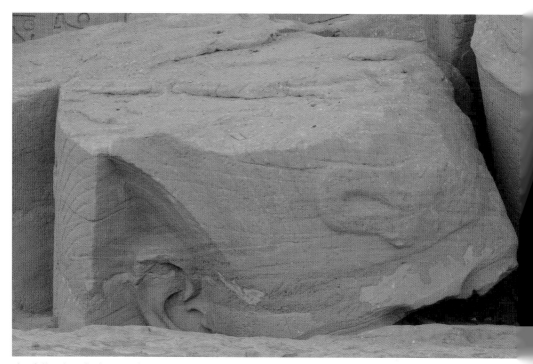

The fallen head of one colossus

Opposite: The southern colossus

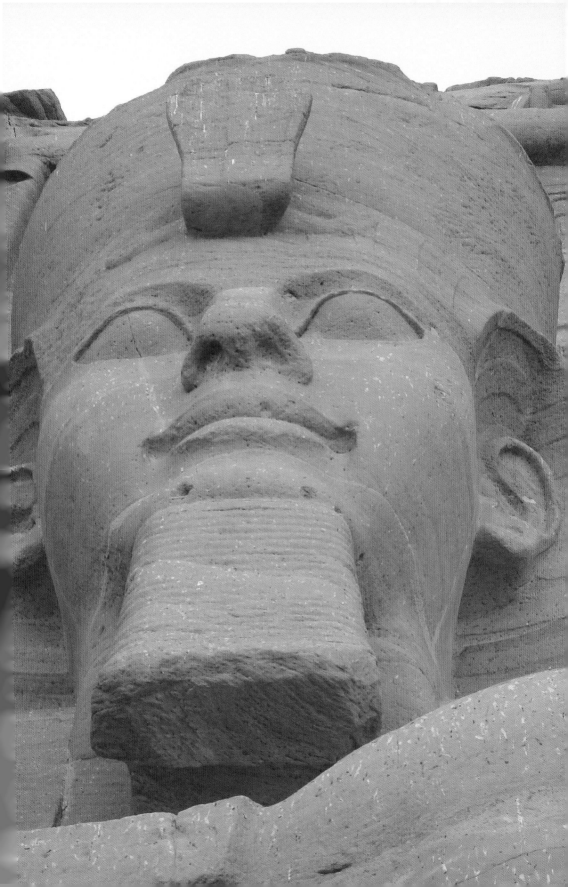

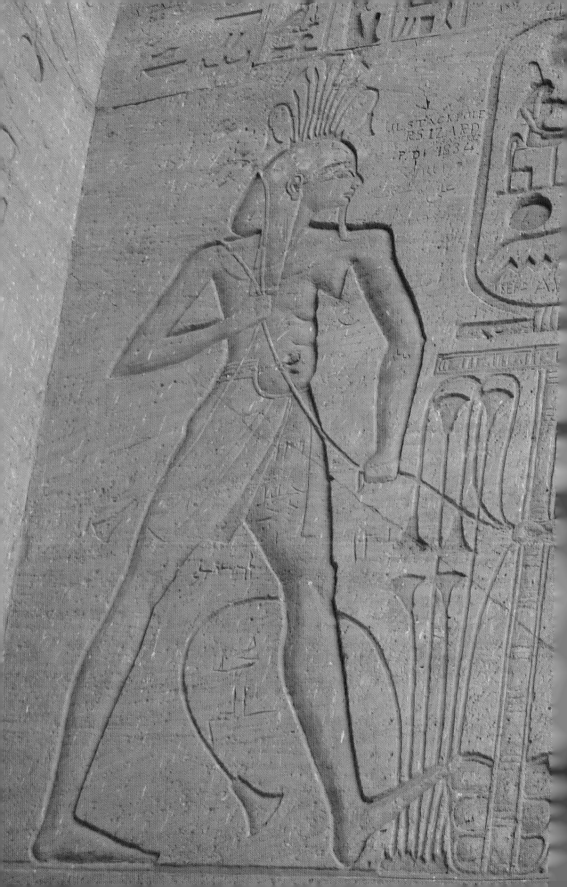

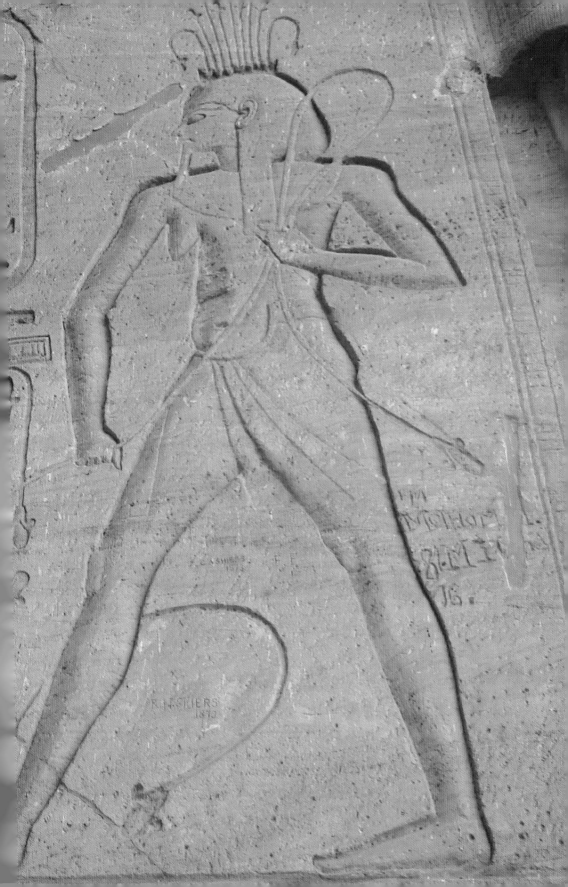

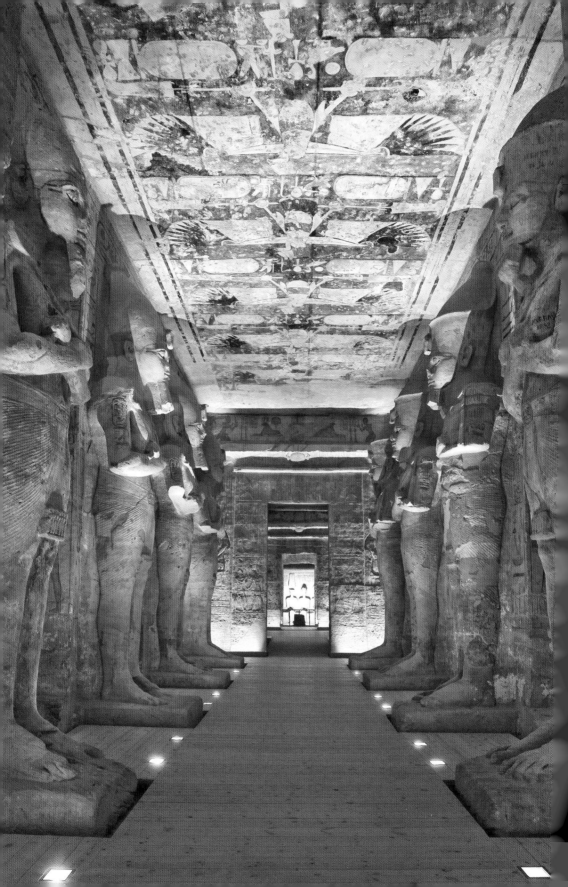

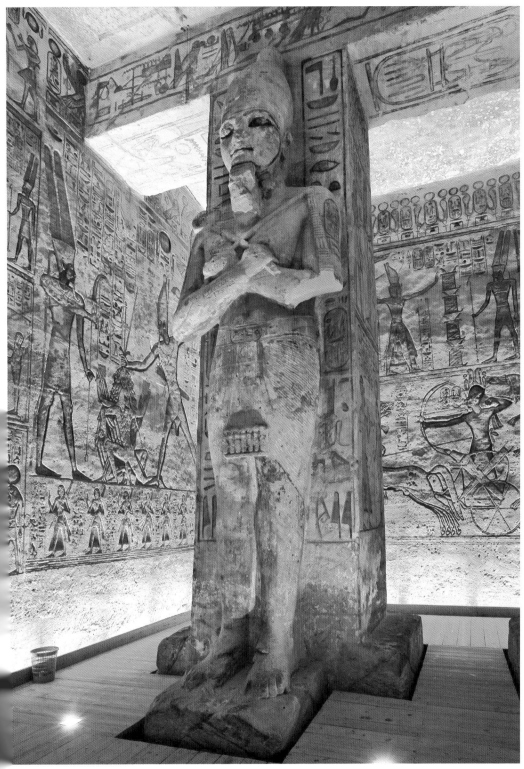

Above and opposite: Osiride statues of Ramesses II inside the Great Temple

Previous pages: The Nile god Hapi unites Upper and Lower Egypt on the façade of the Great Temple

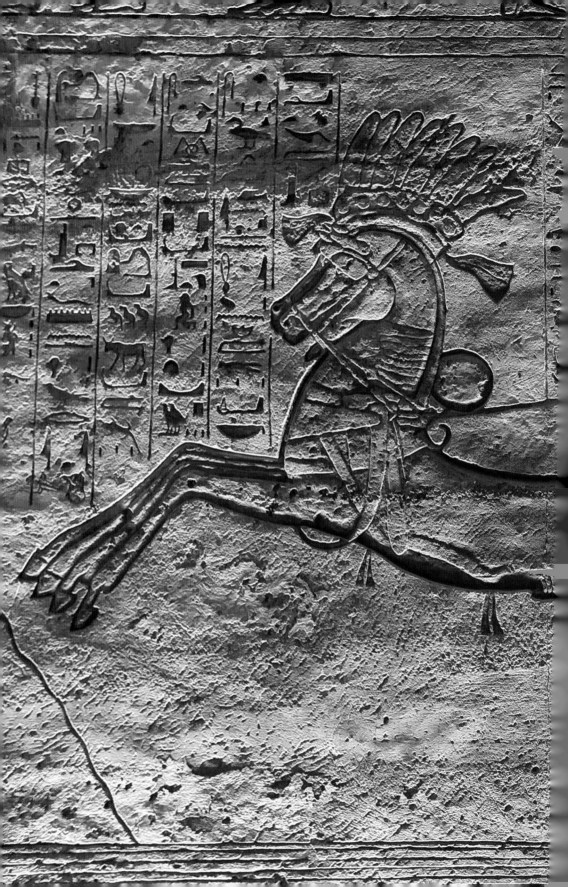

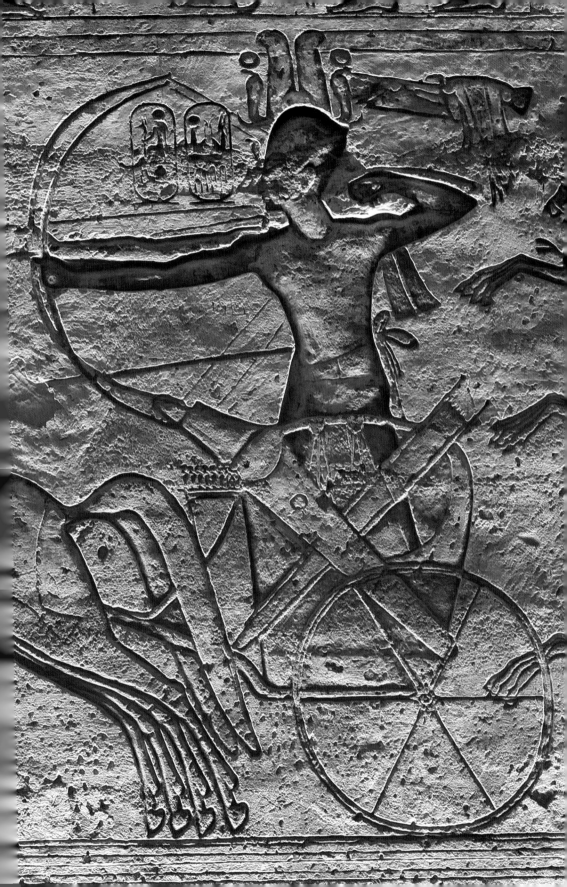

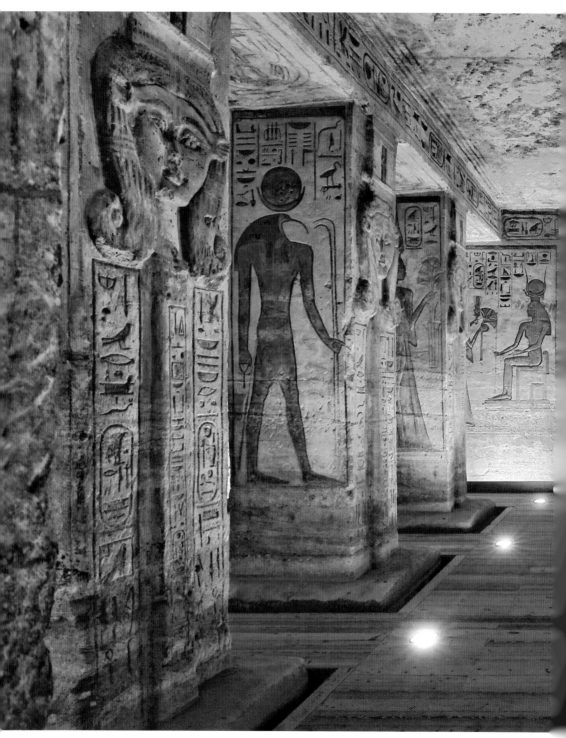

Previous pages: Ramesses II goes to war on the walls of the Great Temple

Above and following pages: Inside the temple of Hathor

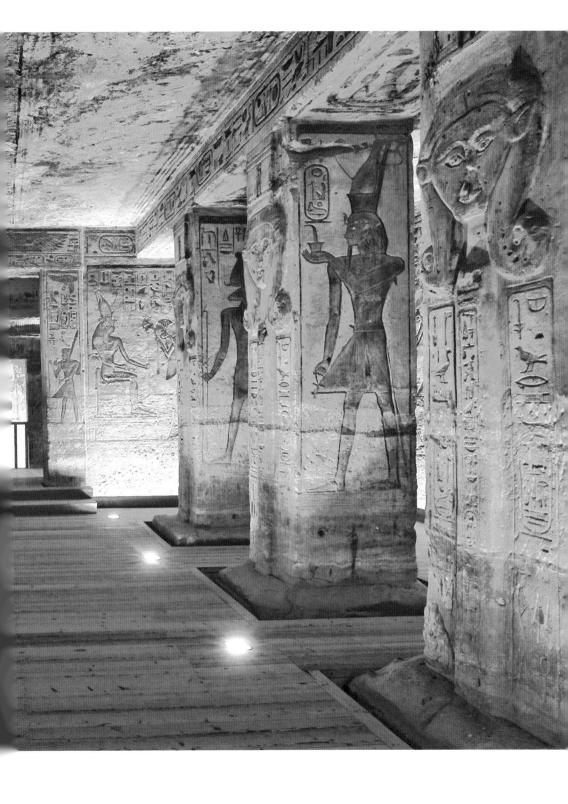

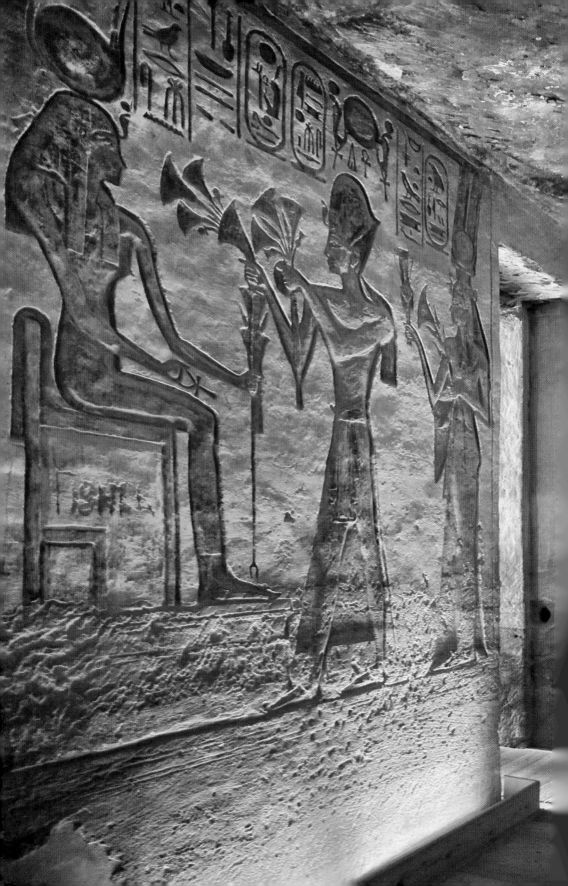

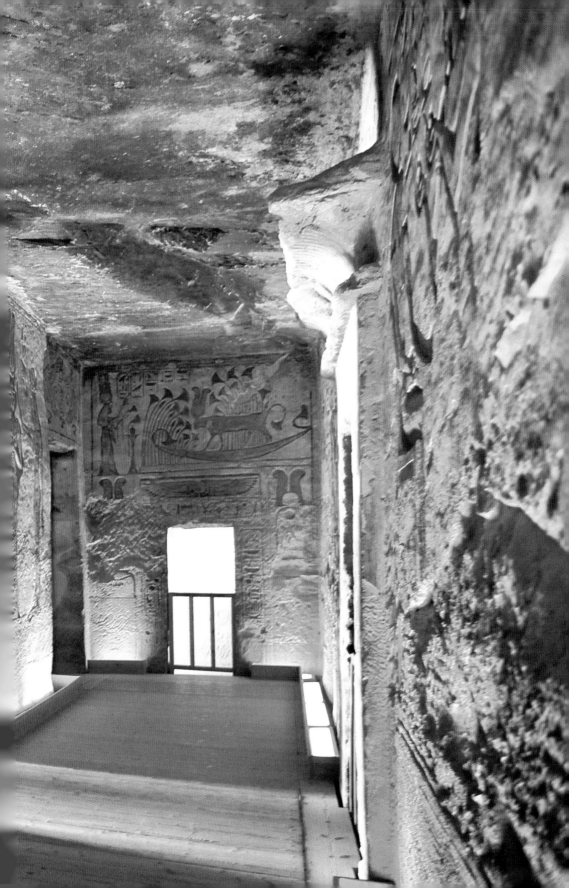

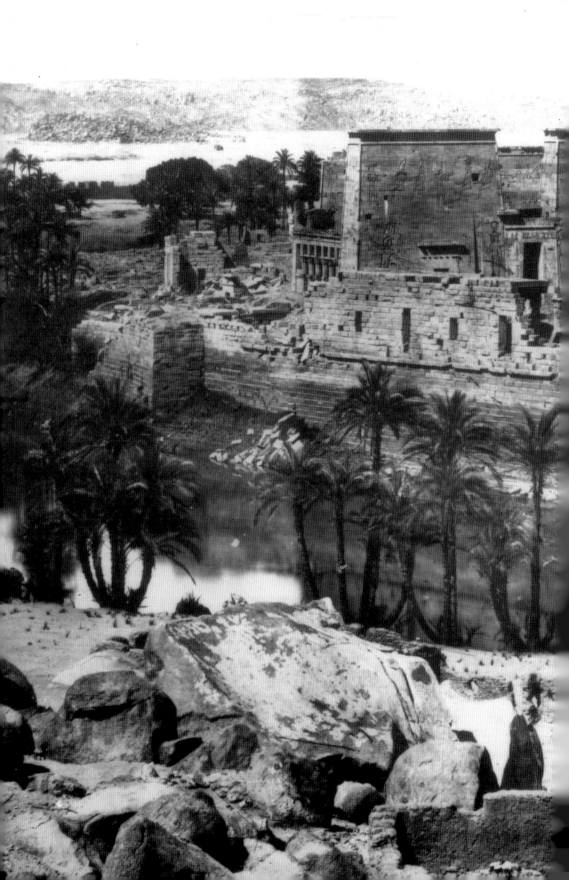

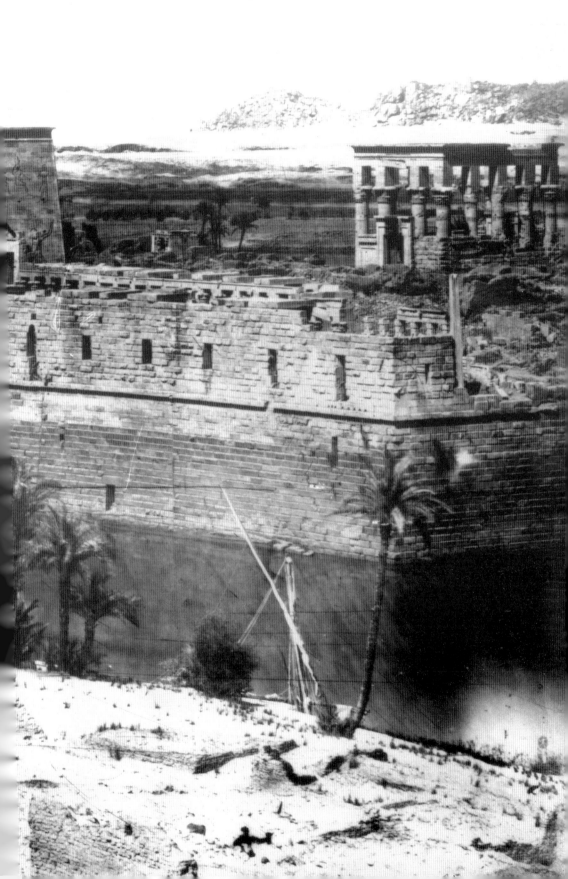

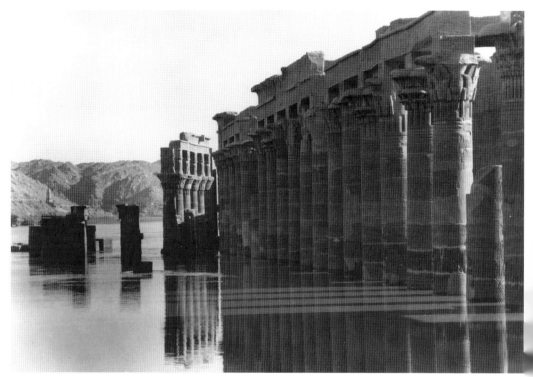

The temple of Isis on Philae before its relocation to a higher island

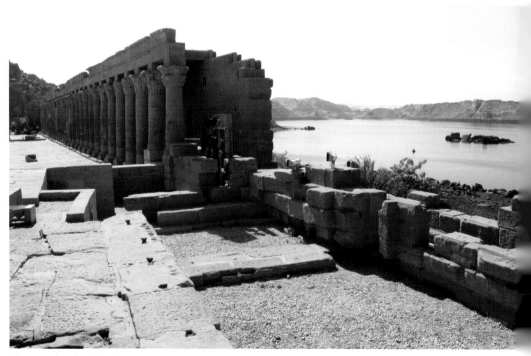

The temple of Isis in its new location

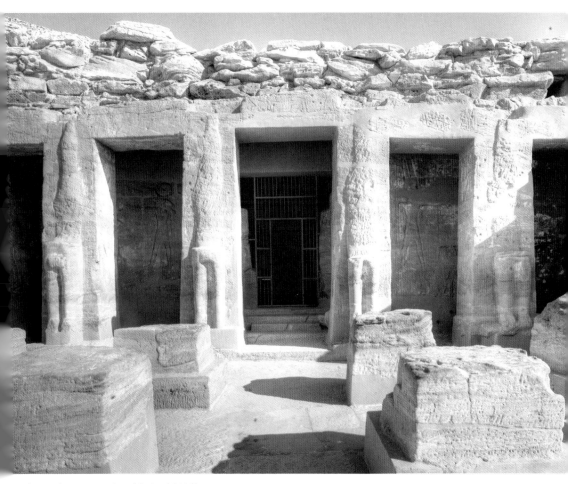

The rock-cut temple of Beit al-Wali

Previous Pages: The island of Philae in the late nineteenth century

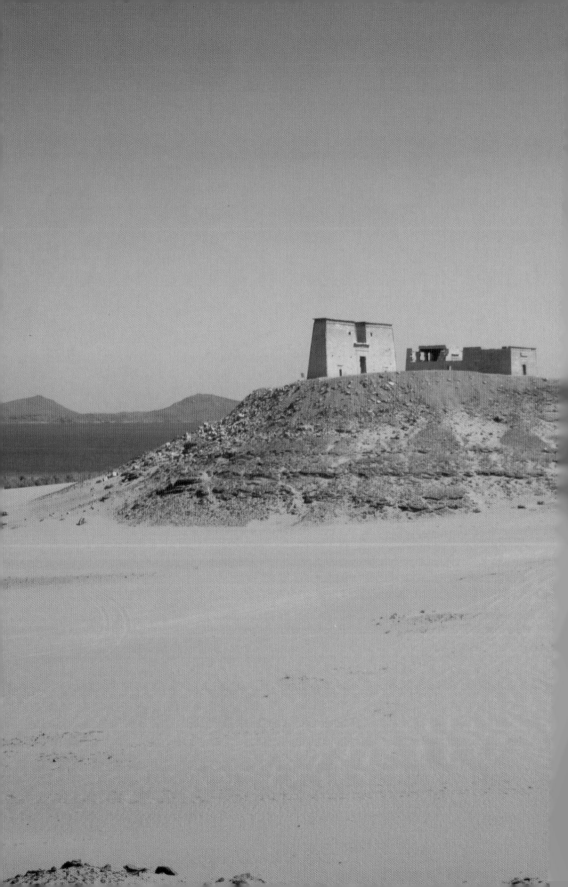

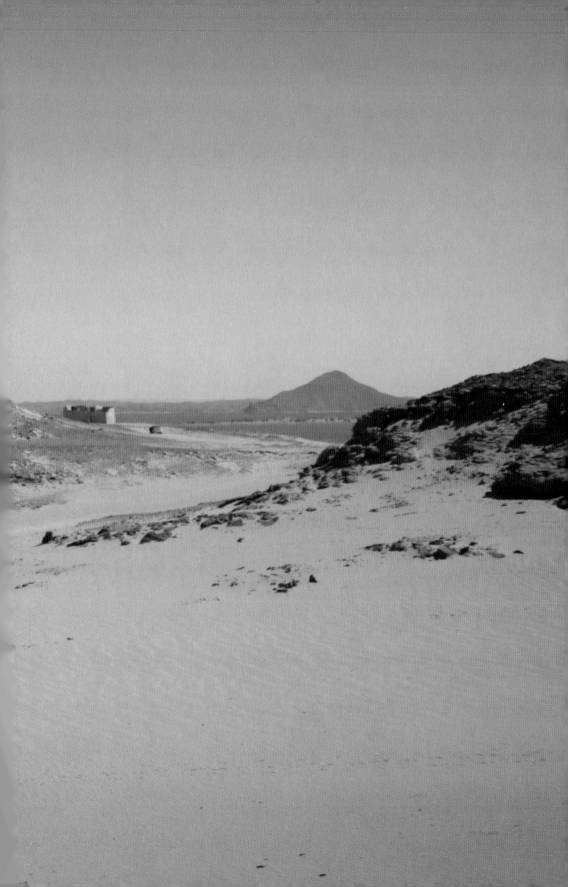

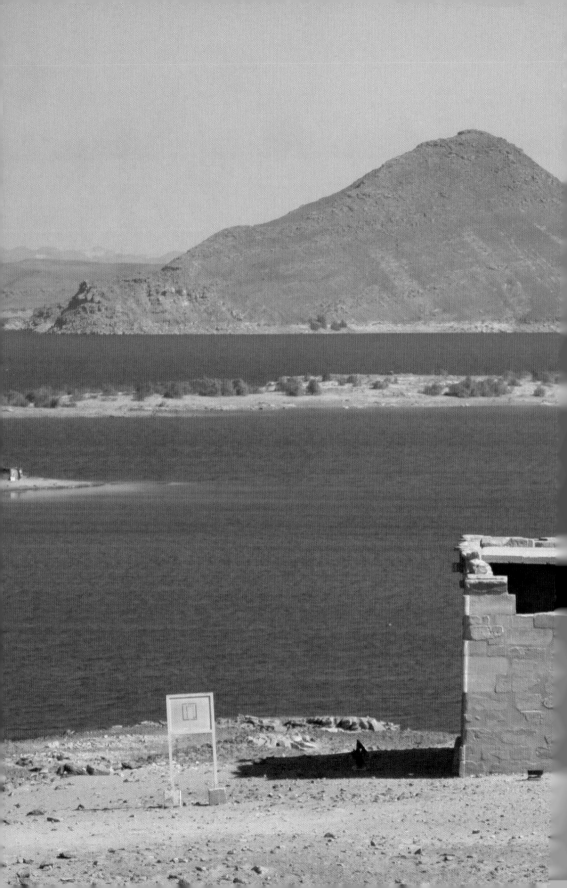

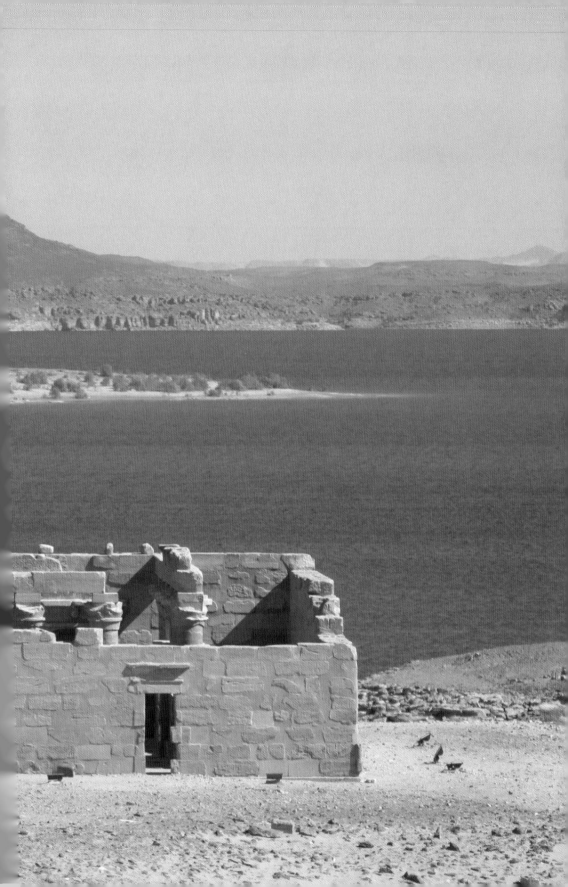

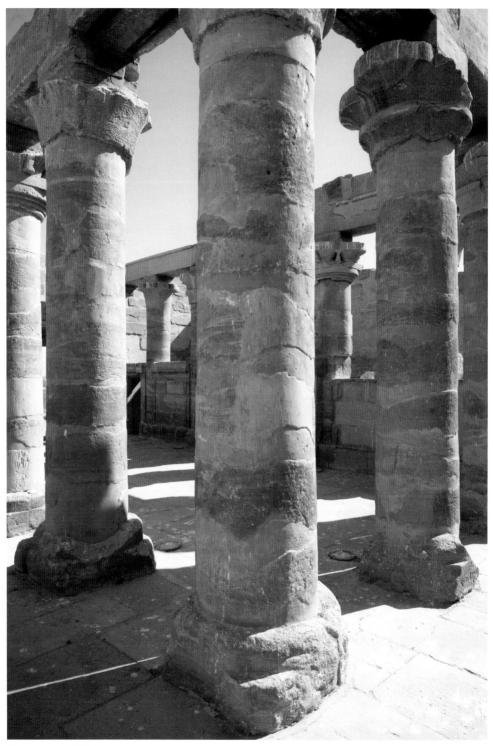

The temple of Maharraqa

Previous pages: The temple of Dakka and the temple of Maharraqa on Lake Nasser

Opposite and following pages: The temple of Wadi al-Subua

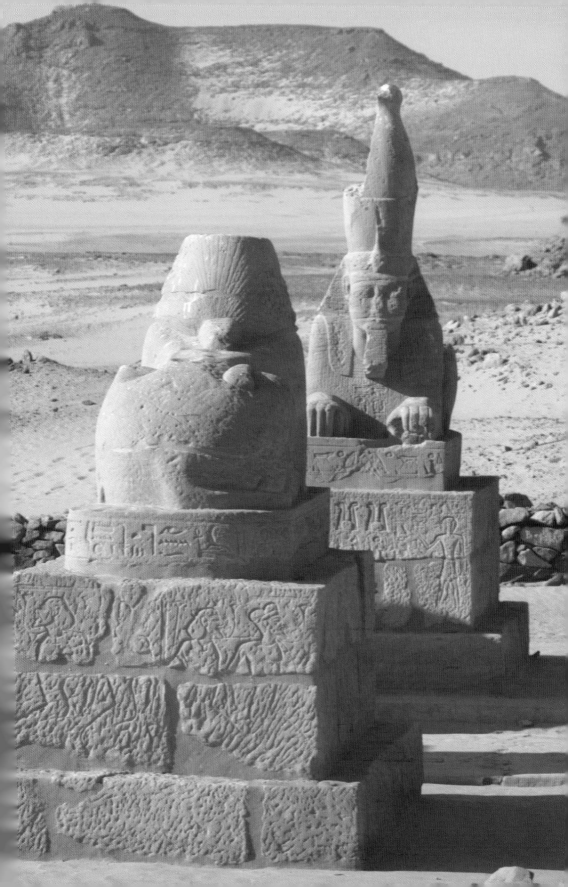

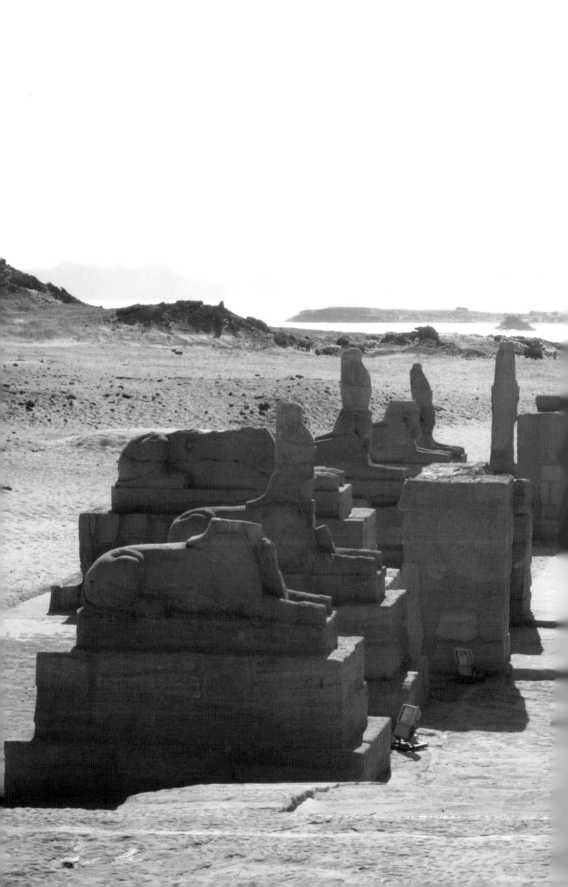

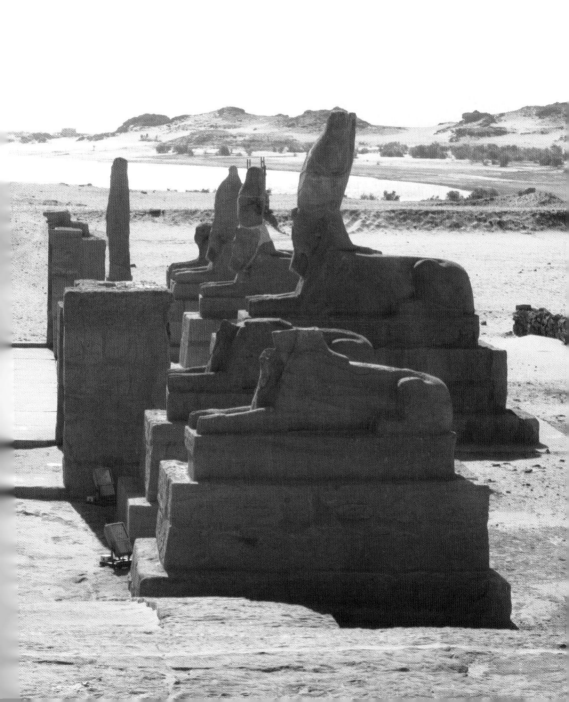

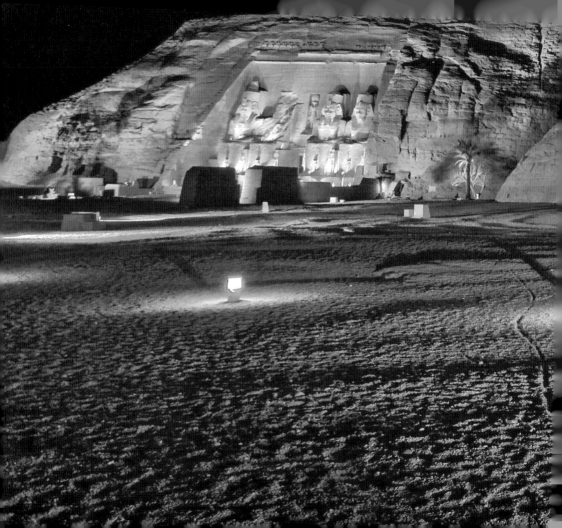

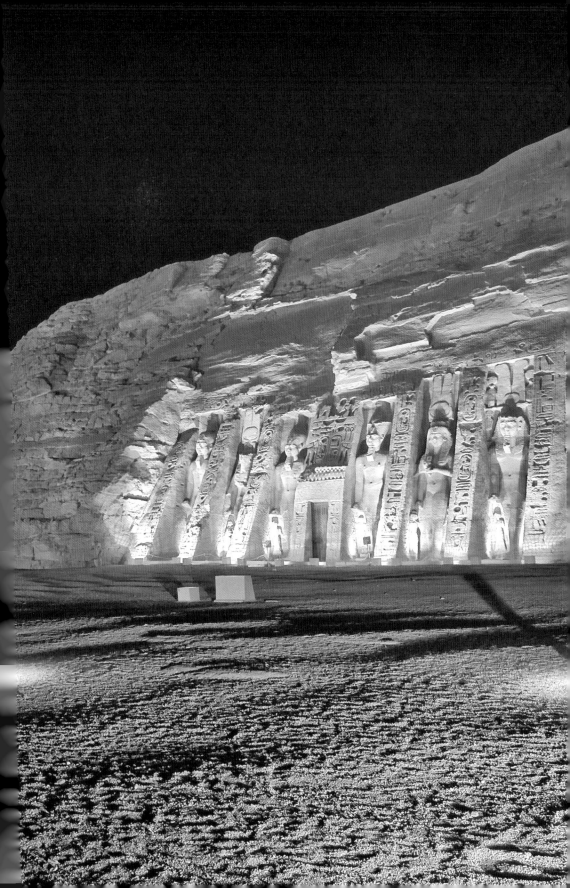

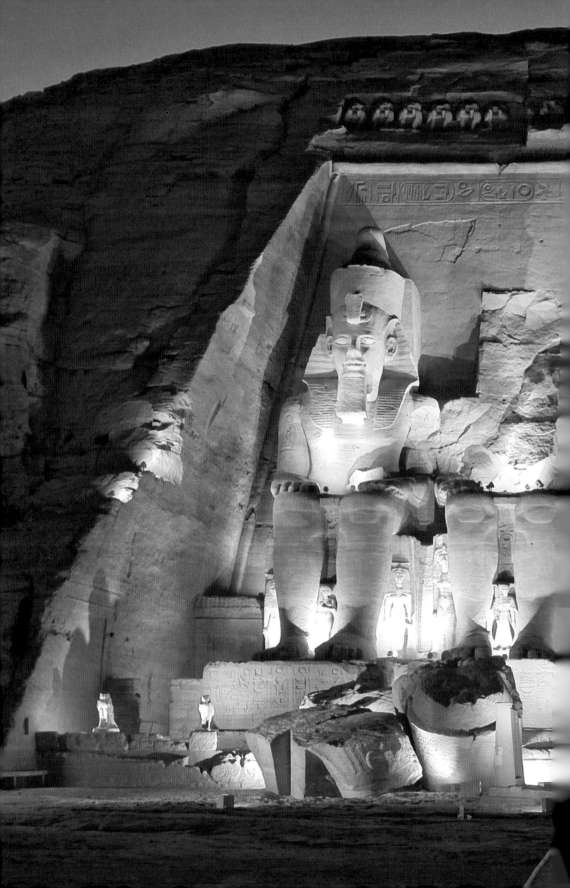

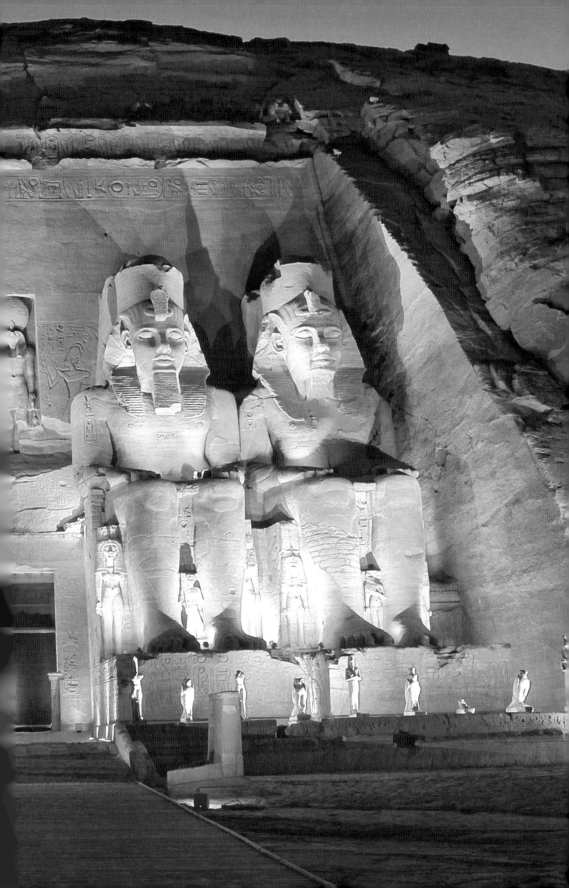

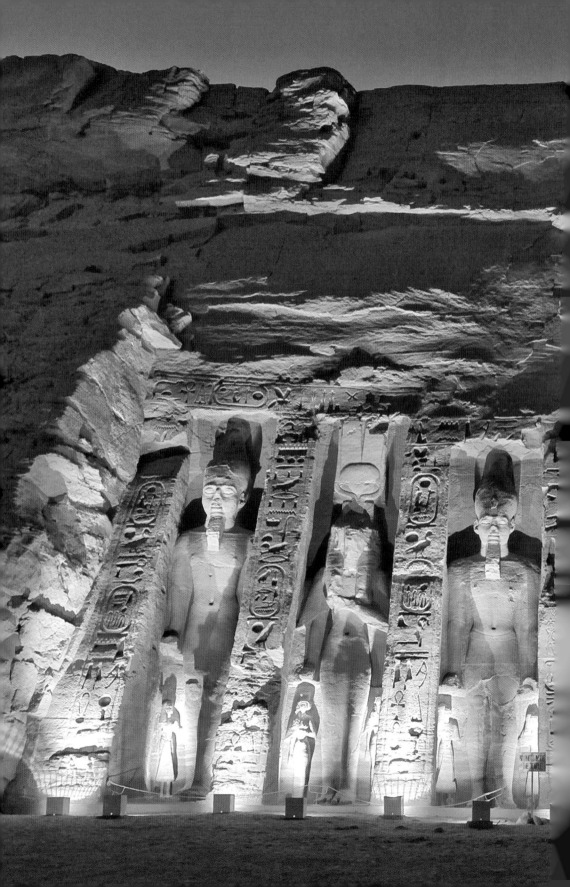

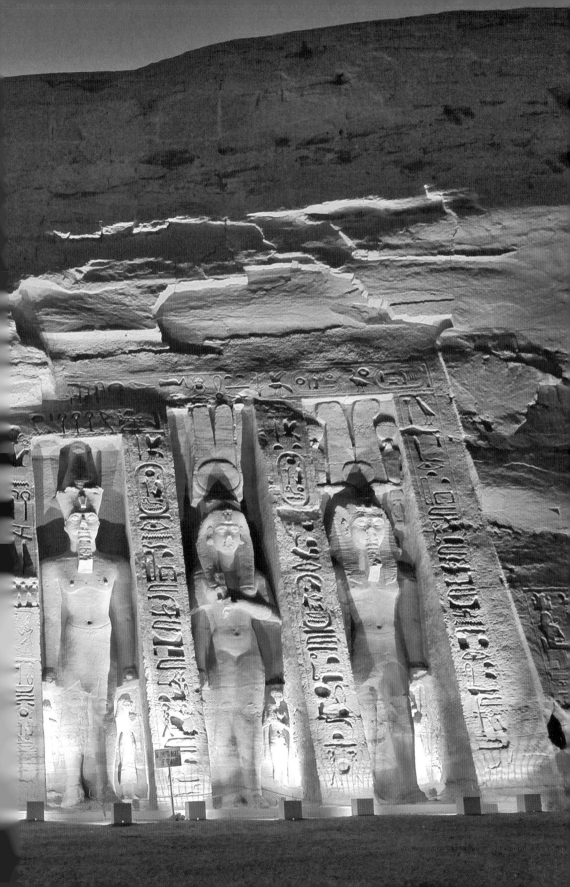

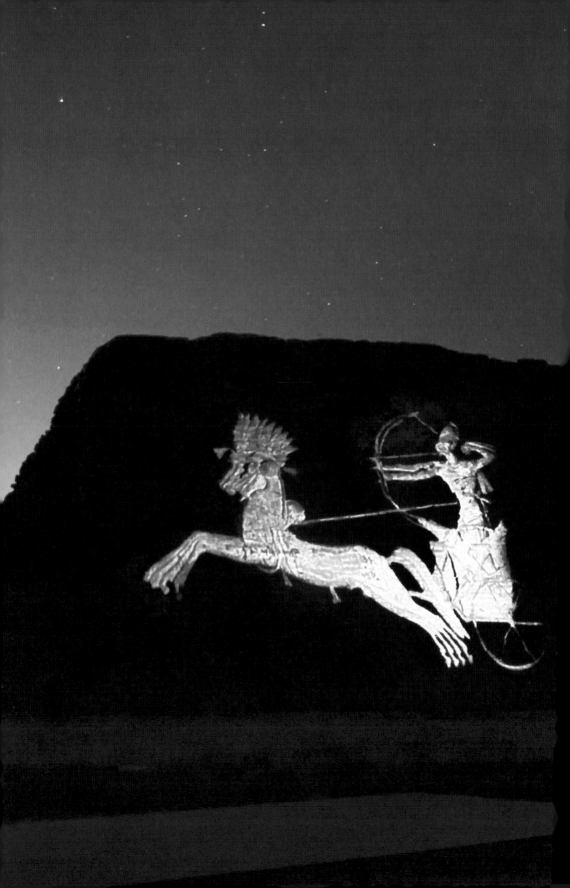

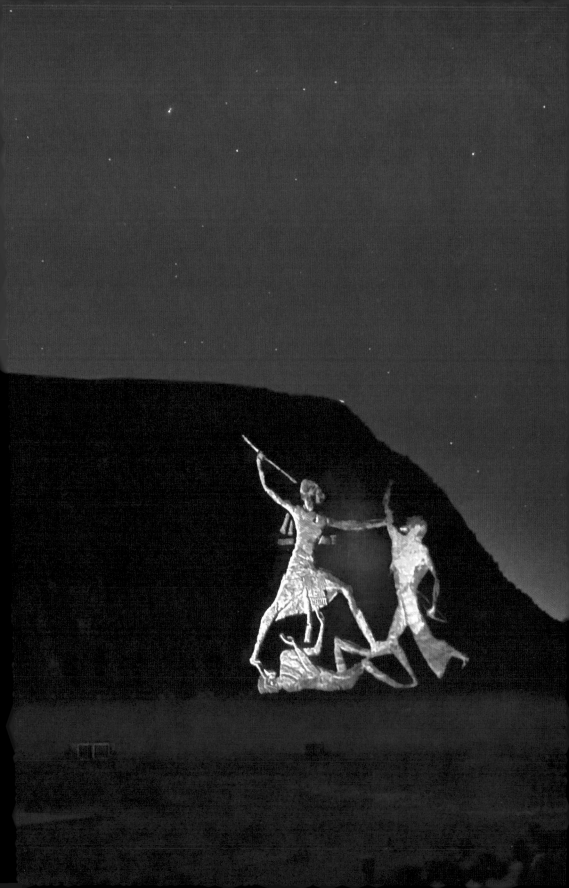

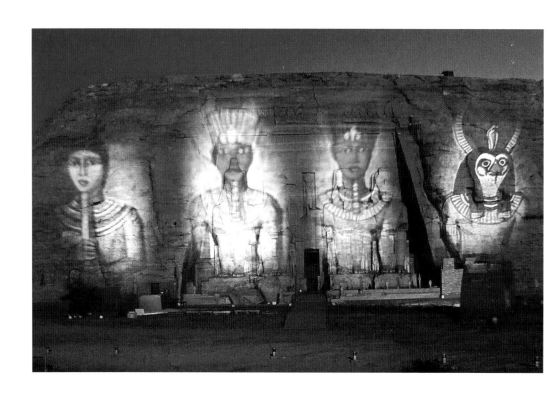

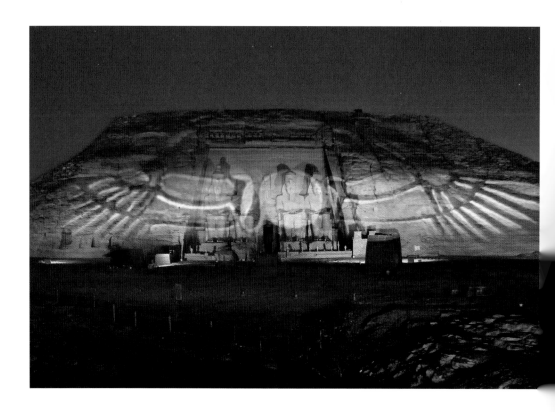

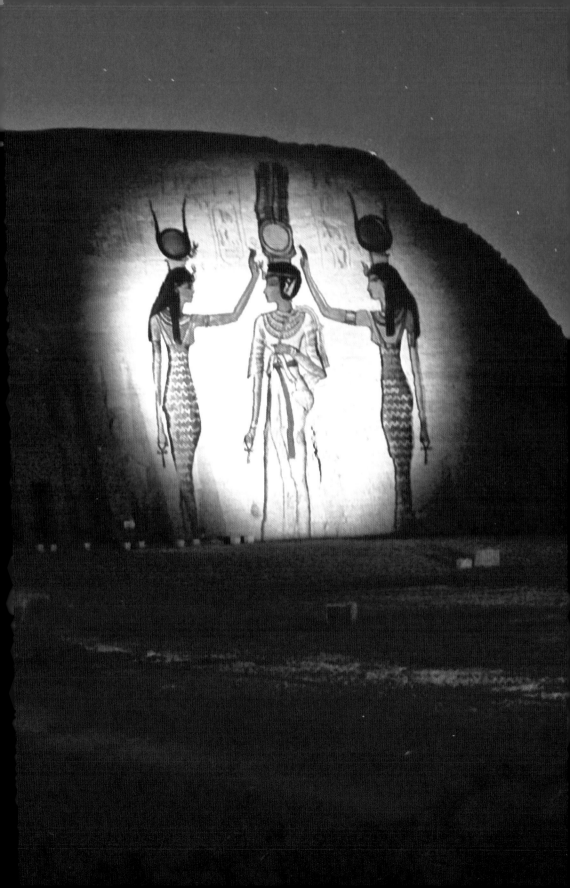

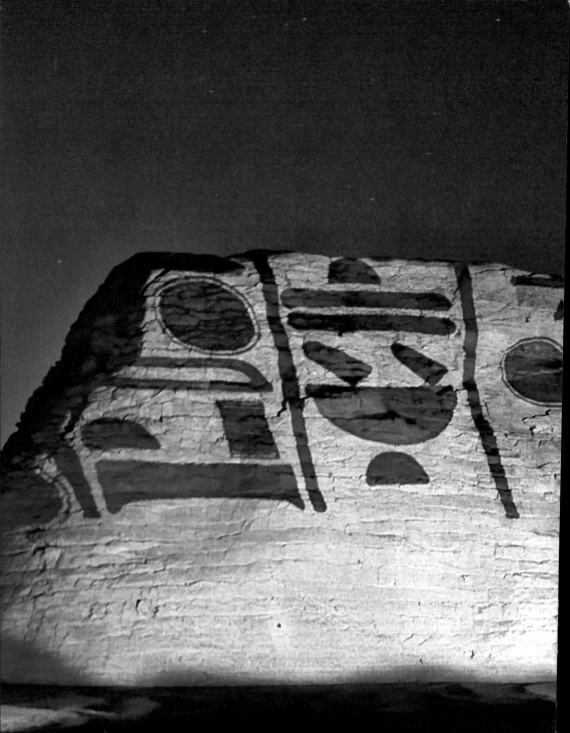

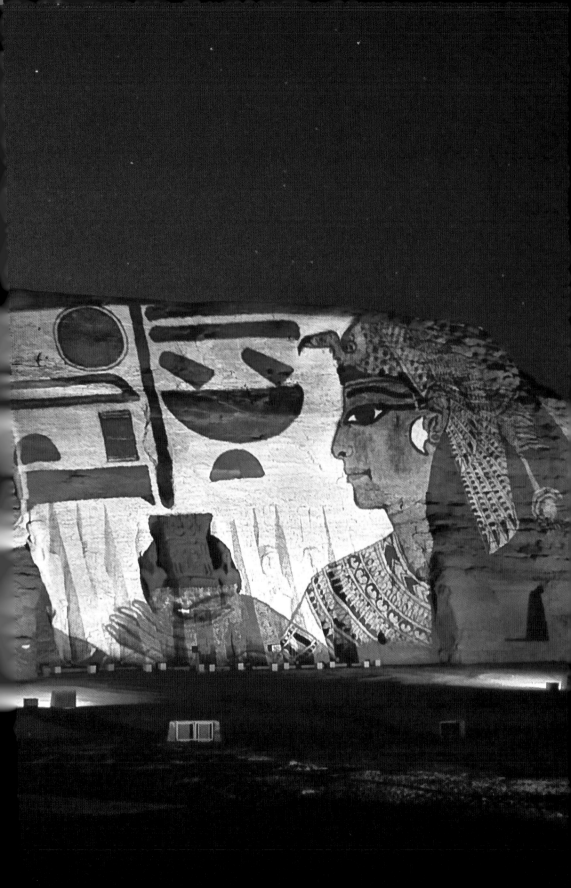

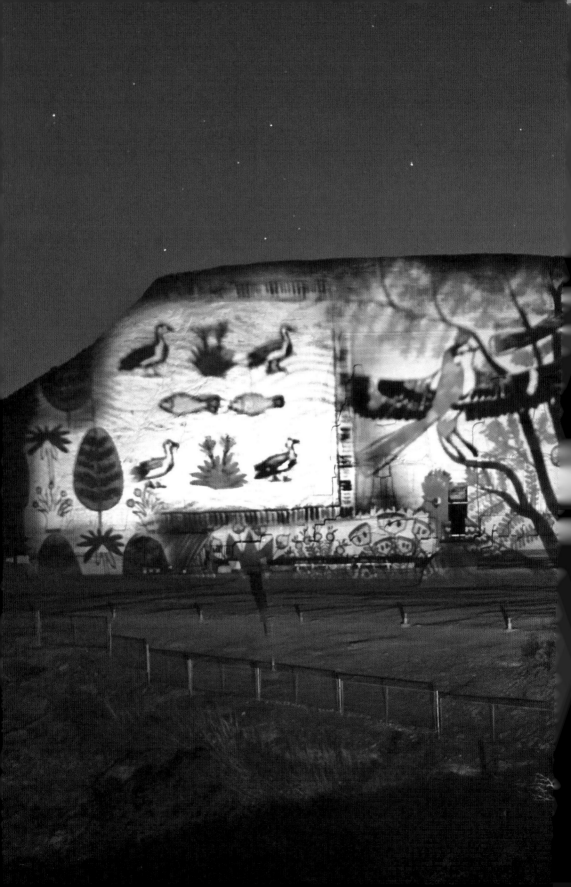

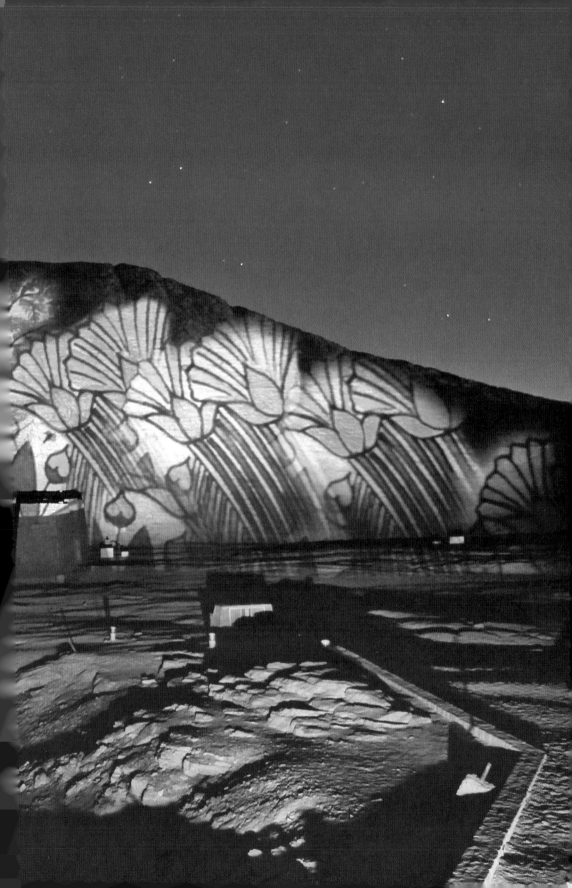

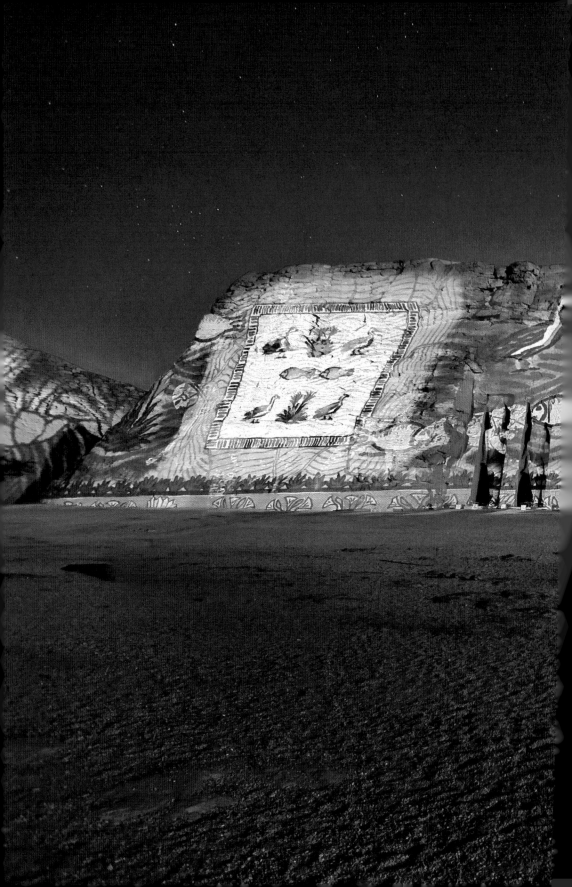

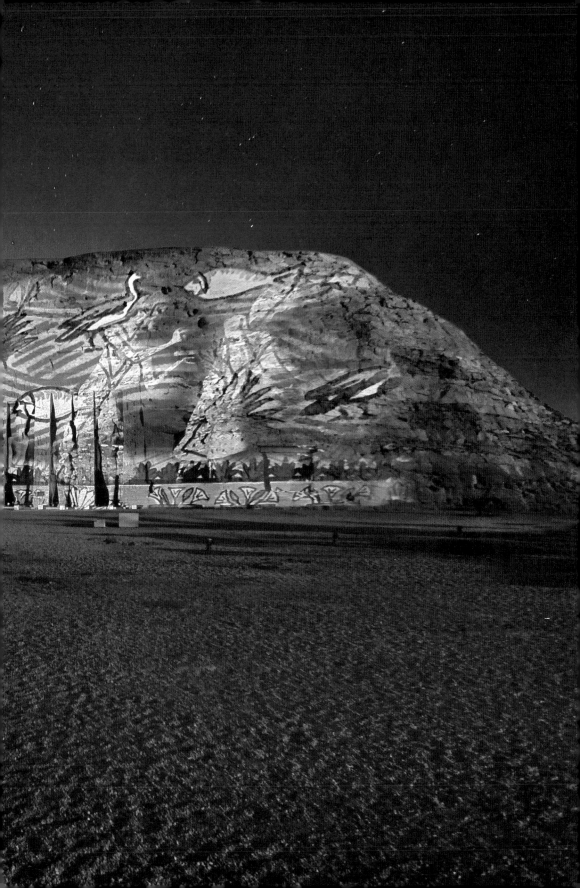

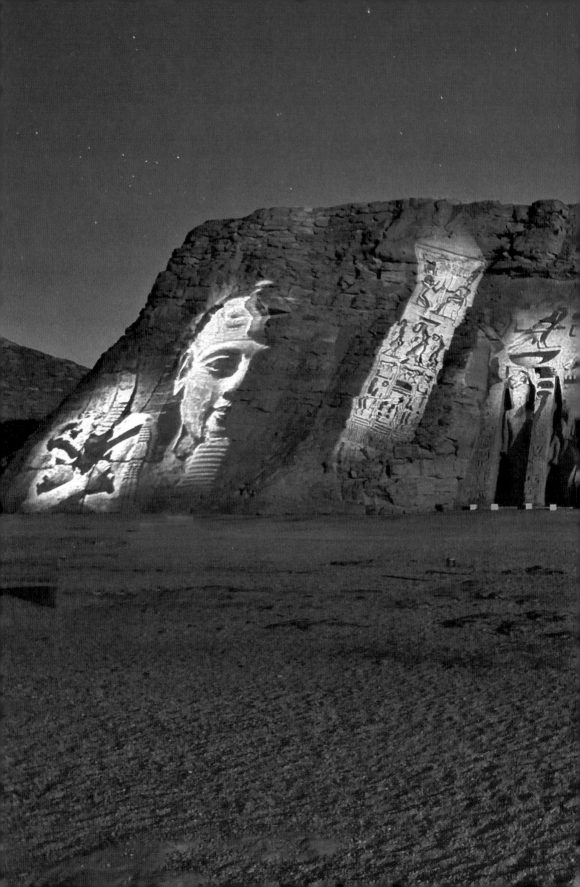

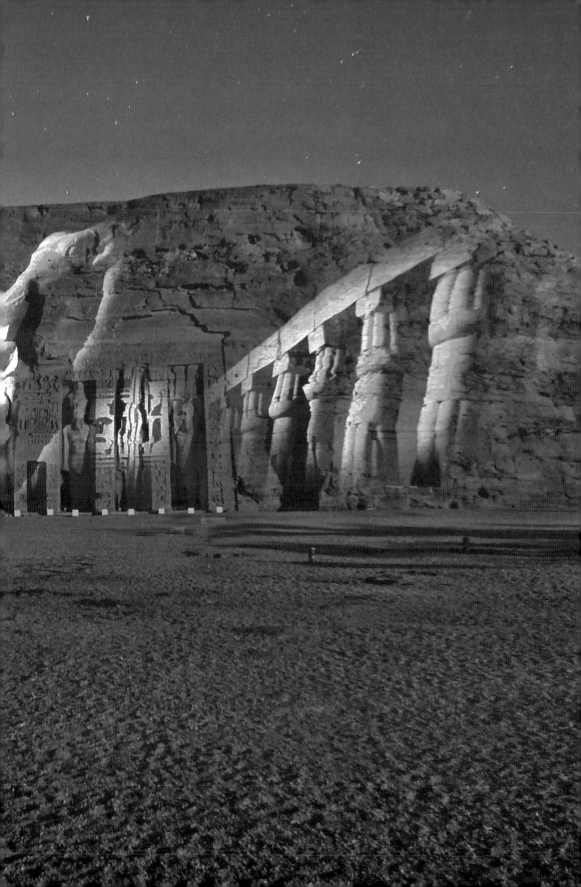

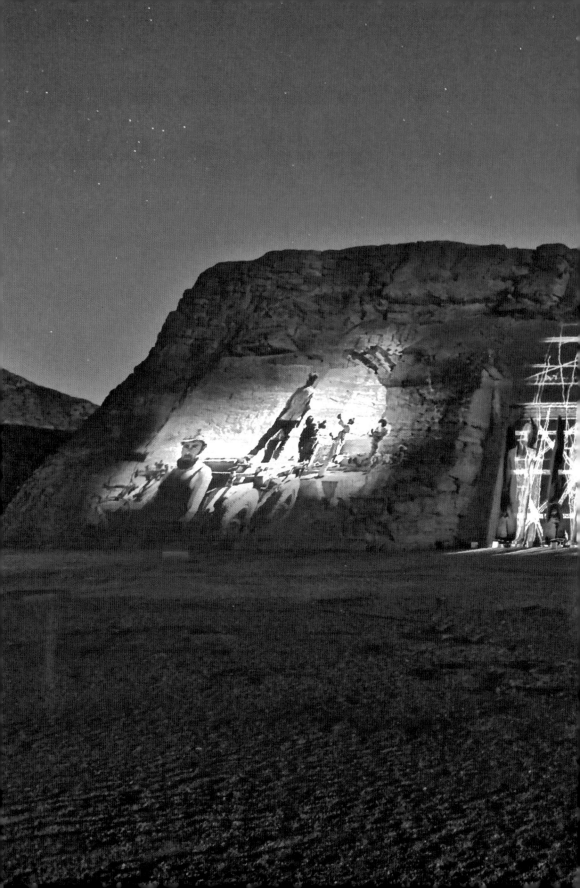

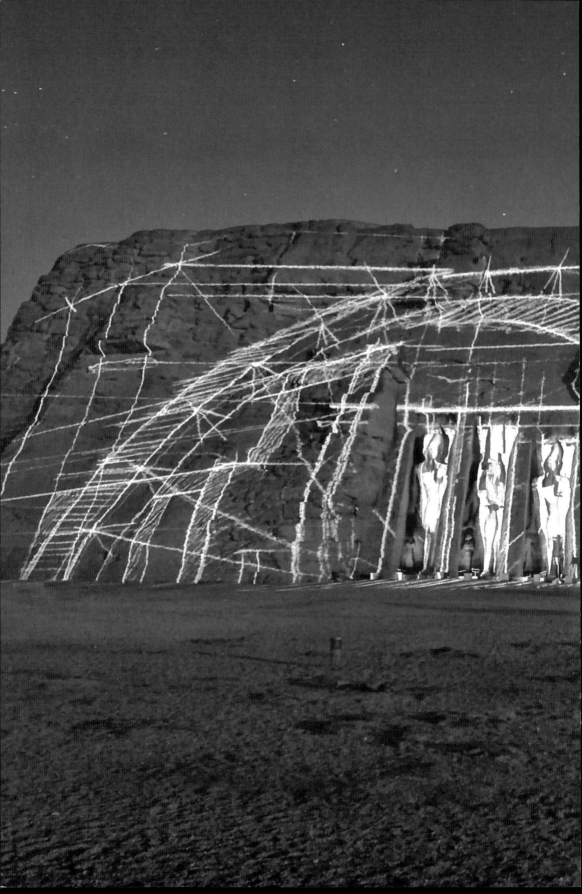

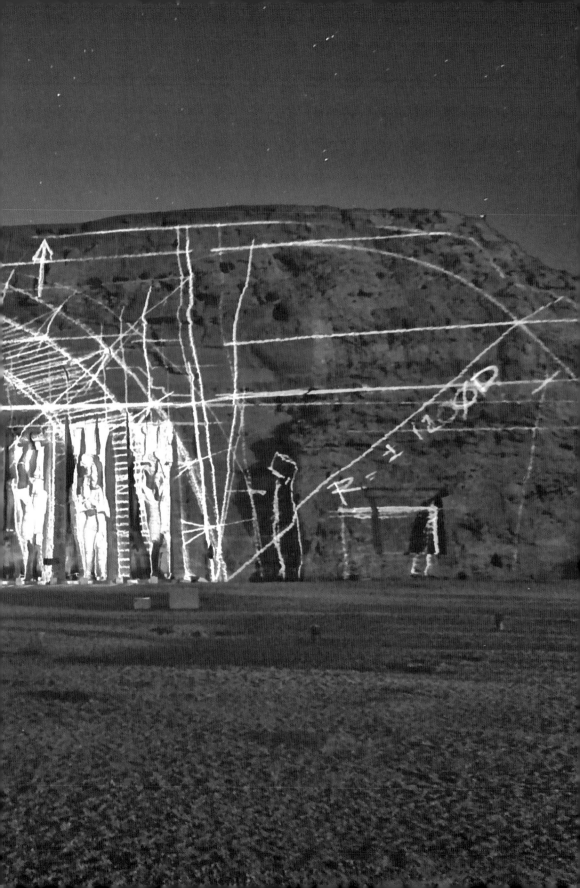

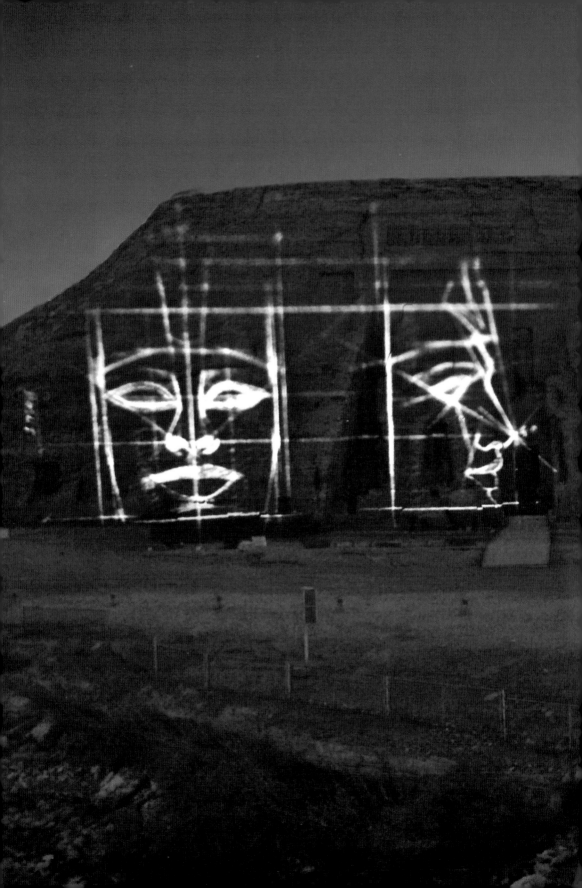

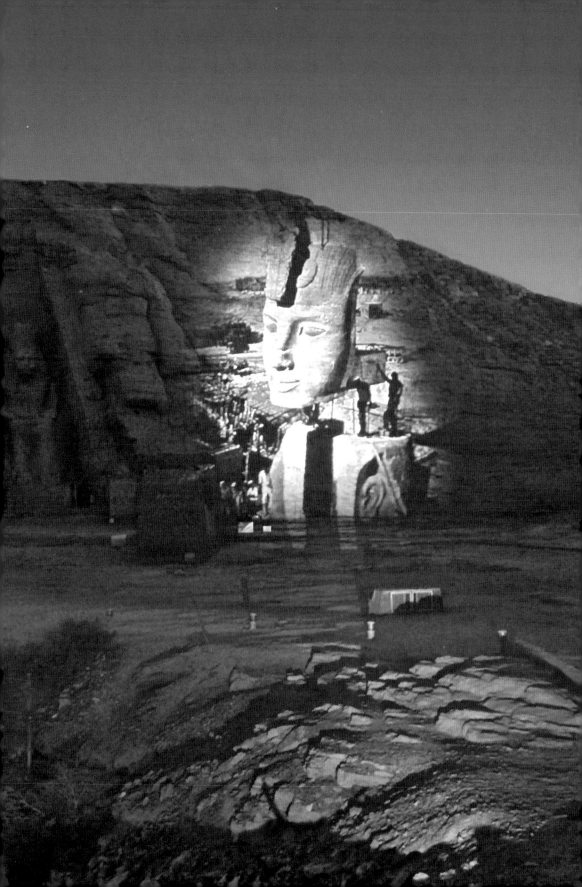

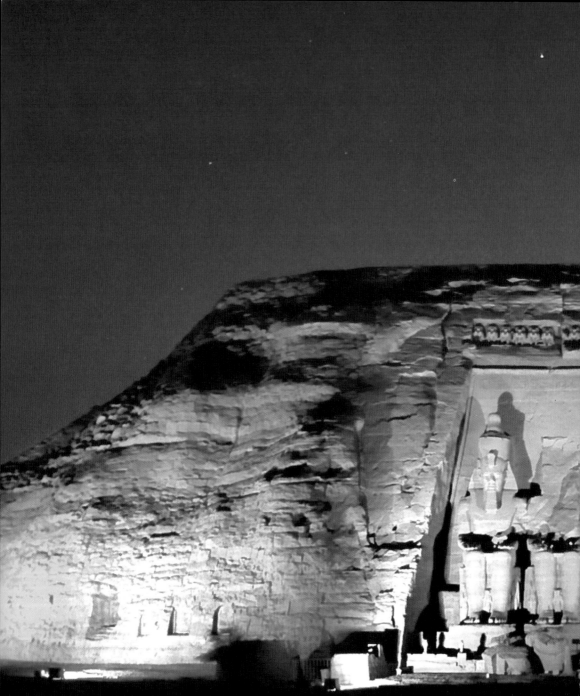

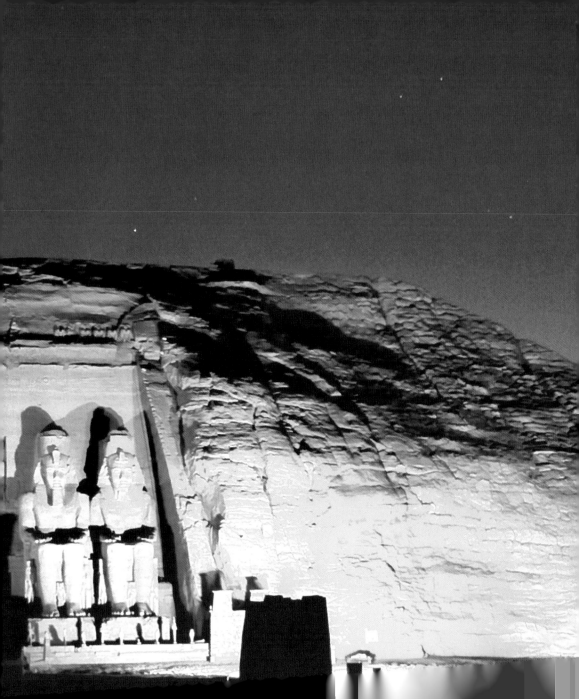

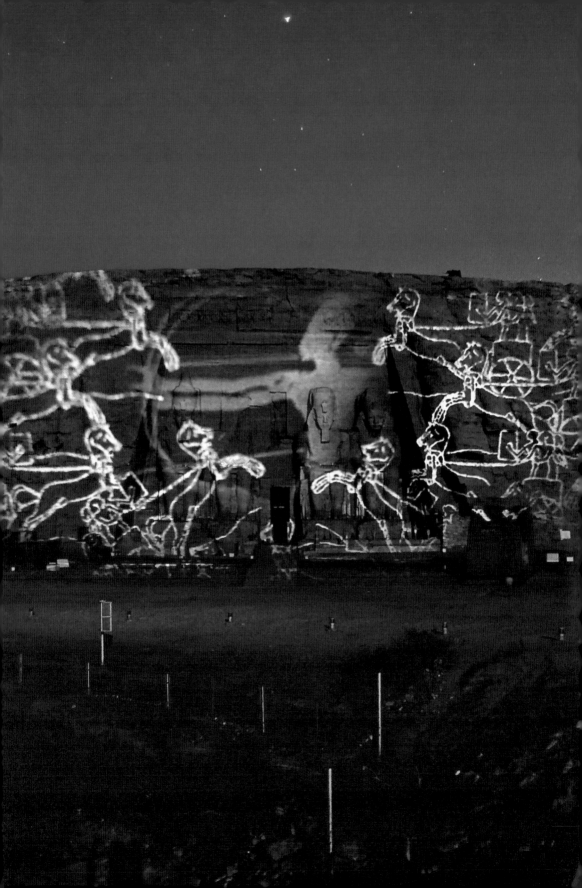

The Abu Simbel Temple Sound and Light Show

Discovery
THE WIND OF THE HISTORY
(Presentation of the wind)

WIND
How beautiful is the dark cloak of the night.
I like to play with its silence
and caress the never-ending sand with my song.

They say I bewitch man,
that my voice is a silk whisper,
a far legend, like the gust of centuries,
an endless flight to the mists of memory
and the dunes of oblivion.

It is possible; I am the desert's spirit.
But maybe it's just a dream:
I am, only,
the wind.

Discovery
THE WIND OF THE HISTORY
(The discovery)

WIND

It is true, I am witness to history.
For more than three thousand years I have loved
this privileged spot of profound Nubia.
My embrace hid its secret a long time ago,
but its memory continued to pulse below
the waves of the desert.

But, at the beginning of the nineteenth century,
Egypt fascinated a deeply affected West.

Man's desires have always moved me.
One day I raised a little breeze,
and their eyes,
trembling with astonishment,
discovered a thousands of years old wonder:
the temples of Abu Simbel.

Salvation
THE CONTEMPORARY EPOPEE
(The river)

WIND

The Nile . . .
My eternal companion has blessed these banks
from the dawn of the world

The passage of civilizations,
the course of the stars,
dawns and dusks are reflected in the flow of its foam.

Then, halfway through the twentieth century,
a rumor reaches the hills.
an alarm that breaks
the peaceful dreaming of its waves.

What sort of restlessness is this?
A shiver goes through the water.

An ominous danger hovers over the temples.
An irreparable ravage.
Utter and imminent damage.

Beware, beware my Nubia!

Salvation
THE CONTEMPORARY EPOPEE
(The international campaign)

THE CONTEMPORARY MEN

Today, the eighth of March 1960, UNESCO responds to the call of Egypt to rescue the monuments of Nubia.

The work on the Great Dam has begun.

Within five years, half the Nile's valley will have been transformed into a vast lake.

Prodigious buildings that appear Amun the most admirable on the planet find themselves in danger of being submerged in the waters.

However, this great construction will give prosperity to the people of Egypt.

Egypt is a gift of the Nile.

May the peoples and nations of the world unite in an effort of brotherhood,
to prevent the Nile, source of fertility and energy,
from becoming the watery grave of some of the wonders of civilization, the heritage of all humanity.

Salvation
THE CONTEMPORARY EPOPEE
(Inauguration)

WIND
Believe me, I admire mankind deeply.
Thanks to the effort of you all, the temples are safe.
September 22, 1968,
this contemporary Odyssey is completed.

THE CONTEMPORARY MEN
We have come, oh Pharaoh, to preserve your search for eternity.
Filling our spirits with your desires and rites, we have emptied the mountain down to the heart of your temples.
Then again we have built in light what you had dug in darkness . . .
And we have discovered that, in human works, eternal is only that which makes sense and has value for all mankind.
When we are not here anymore, man will continue to come and dream at your feet.
Then tell them, Lord of Upper and Lower Egypt, how nations united when the waters threatened to submerge you and, opening the mountain, took your colossi in their arms and carried them high up the cliff, so that you, son of Ra, could bear witness to the magnificence of human brotherhood.
Today you are safe, ready to start your journey again along the centuries, towards the rising sun of each morning.

Ramesses and Nefertari
THE SWEETEST
(The king and the queen)

WIND

This new splendor takes me back to the old days,
to the times of the Nineteenth Dynasty.
A King carved his destiny.
The greatest of the Pharaohs:
Ramesses!
I remember his passion, his strength, his iron will.
And I remember the first Great Royal Lady,
The sweetest of his Queens,
for whom the sun shines:
Nefertari.

Ramesses and Nefertari
THE SWEETEST
(The voyage on the Nile)

NEFERTARI

How pleasant is the scent of the wild mimosas,
my Lord.

RAMESSES

My beloved,
Nothing can compare with the
intriguing fragrance of your skin.

WIND

The royal entourage glide their vessels down the river.
Nubia gives them refuge at her bosom.

NEFERTARI

My Lord,

the radiant beauty of this landscape is stunning.

The air is brilliant as the purest crystal.

RAMESSES

Nefertari . . .

Beloved of Mut,

Beauty above the beauties.

You are the Lady of the Lands.

WIND

The geometry of the sails,

gently pushes the royal boats.

NEFERTARI

Look at the long wake we are leaving behind.

Yesterday it had amethyst shades,

Today it is of a turquoise color.

RAMESSES

How long is your neck . . .

Your bosom radiates . . .

Your hair is lapis lazuli . . .

And a balm is the touch of your skin.

WIND

On its way, the riverbanks adorn the Nile

with gold-colored sand.

NEFERTARI

The sky merges with the water in a golden flood . . .

A thin and bright sheet crosses it . . .

RAMESSES
It is the sun's farewell.

Ramesses and Nefertari
THE SWEETEST
(The temple of Nefertari)

WIND
Here, at the gate of Egypt,
two sanctuaries celebrate the glory of the royal couple.
Ramesses, as god of the Sun, and Nefertari,
as the divine star Sothis,
create every year, magically,
the sacred floodings.

NEFERTARI
My Pharaoh . . . it is me!
And our children around us!

RAMESSES
The temple is dedicated to you and to the Goddess Hathor.

NEFERTARI
I am represented by her ritual crown.

RAMESSES
Yes. The Sun disc, the plumes, and the horns of the sacred cow,
symbols of Hathor.
The Goddess of heaven and fecundity
is both mother and wife of Amun-Ra,
the Sun God.
I want our union to be eternal.

Ramesses and Nefertari
THE SWEETEST
(The great temple)

NEFERTARI

The great temple.

RAMESSES

It is my wish to create a sublime expression
of the solar universe.
A magnificent altar where the Pharaoh is the Sun.
The image of Ra-Horakhty is the symbol of my power.

NEFERTARI

Surely, the divine dwells in you, my Lord.
You reign in heaven, on earth and in the waters of the river.
Your glory is the glory of Egypt.

RAMESSES

Ptah, the Creator,
Amun, the Hidden,
Ra, the Splendor.
The three are one,
and I, their bond, their union:
Ramesses, Great of Victories.

NEFERTARI

Supreme Sovereign,
You are Master and Lord of the Pantheon.

RAMESSES

A ritual will revitalize the divine flame.
now and forever.

Twice a year, the ray of the rising sun will run through the halls' darkness
into the holy of holies.
and illuminate the sacred chamber.
While Ptah rests in the shade,
Amun and Ra will transmit to me the warm celestial spirit,
the primeval Being.

NEFERTARI
King of eternal time . . .

RAMESSES
Yes, I am Pharaoh.
I am God.

Heroic Ramesses
LIKE A TEMPEST IS THE BATTLE
(The first campaigns)

WIND
Fire of combat,
The defense of the Empire,
The invasion of the Hyksos starts four centuries
of continuous aggressions.
Ramesses inherits the warrior blood of his ancestors.
He who disrupts peace is destroyed.

RAMESSES
I have crushed the foreign enemies,
banishing evil beyond the frontiers.

WIND
In the north, in the south, to the east, to the west,
the protective conquests,

the heroic deeds, the victories . . .
The trails are triumphant.
The tributes are immense.

RAMESSES
A prelude of glory.
The Kingdom of Hatti is the loathed rival.
And in the fifth year of my reign,
the city of Qadesh will be the inevitable encounter.

Heroic Ramesses
LIKE A TEMPEST IS THE BATTLE
(Qadesh I. Preparation)

WIND
Infantrymen, archers, charioteers,
proud chargers with trembling nostrils.
The four divisions of the Empire.

Countless are the troops of the Hittite.
His chariots, terrible, infinite,
embark on a brutal and unbridled enemy gallop.

Heroic Ramesses
LIKE A TEMPEST IS THE BATTLE
(Qadesh II. The prayer)

WIND
Abominable cavern!
Black grip of death!

RAMESSES

Father Amun,

a multitude of enemies surrounds me.

They come against me from all countries.

I am alone,

my troops have abandoned me.

No one hears my call.

You ordered me to come

and I have obeyed.

Father Amun, I have trust in you.

Help me.

AMUN

Carry on, my son.

My hand is with you.

I prevail over hundreds of thousands of men.

I am the lover of valor,

the lord of victory.

Heroic Ramesses
LIKE A TEMPEST IS THE BATTLE
(Qadesh III. The war continues)

WIND

Like a brilliant ray,

Ramesses decides the conflict.

The foe swallows his pride in a truce.

Campaigns are repeated.

Victories are brief,

the dominion ephemeral,

Cities are gained and lost,

The decisive conquest
that would forever put out the bonfires, impossible

War is a wild and never satisfied best . . .

Heroic Ramesses
LIKE A TEMPEST IS THE BATTLE
(The peace treaty)

WIND
. . . peace, a precious gift of heaven to mankind.

In the twenty-first year of his reign,
the first treaty
reconciles the Egyptian and Hittite peoples.
Ramesses and Khatosil twin their empires.

KHATOSIL
The great king of Egypt, the hero,
establishes peace forever

RAMESSES
The great lord of Hatti,
will never violate the land of Egypt.

KHATOSIL
Against whichever foe
I will be the ally of the great King of Egypt.

RAMESSES AND KHATOSIL
Divine forms of the land of Egypt,
may he who dishonors these words be destroyed,
may he who respects them be prosperous and happy.

Heroic Ramesses
LIKE A TEMPEST IS THE BATTLE
(The Hittite princess)

WIND

An exceptional seal
consecrates concord between the peoples.
In the thirty-fourth year of Ramesses' reign,
The daughter of Hatti and the Pharaoh,
link their destiny.

Anointed with ritual oils,
the flower of the Hittites arrives at the Delta.

RAMESSES

Rose mallows, palm trees, sycamores . . .
Even the Nile is pleased with your wedding,
princess of peace, Queen of Egypt.

Ceremony
THE DAY OF GLORY
(The names of the king)

WIND

The lotus opens its petals,
The papyrus sways its stalk,
The plenitude of the Pharaoh,
is the splendor of his reign.

RAMESSES

Ramesses Meriamun.

WIND

Son of the sun, beloved of Amun.

RAMESSES

That is what Tuya, my revered mother,
Called me at birth.

WIND

Usermaatra,
Powerful is the cosmic order of the Sun God.

RAMESSES

That is what my father and the empire called me,
I was still wearing the infant's plait,
when glorious Sety appointed me co-regent.

WIND

Lord of the Two Lands.

RAMESSES

Memphis, Tebas, and Heliopolis
witnessed my coronation.

WIND

Lover of truth and justice.

RAMESSES

I have constructed useful works for the people
and the gods.

WIND

Virile bull.

RAMESSES

More than a hundred births have pleased my heart.

WIND

The names of the King are the memory of the Kingdom.
For sixty-seven years,
Ramesses will carry the scepter of Egypt.

RAMESSES

When I close my eyes,
the sense of my days and works fills me with a great pleasure.
Amun those, one,
is closest to my heart:
Abu Simbel.

Ceremony
THE DAY OF GLORY
(The inauguration of Abu Simbel)

WIND

It is the night of Ra,
the last of the year.

The fires of thousands of oil lamps
keep vigil all over the Kingdom.

At daybreak
the sun and Sothis will meet once more,
and the annual flooding will arrive.

The divine barge of Amun-Ra,
waiting inside the temple,
will be taken to the royal vessel.

It will travel down the river
for the entire country to adore
the symbol of the floods.

The inauguration . . .
The twenty-fourth year of his reign witnessed
an exceptional ceremony.

High Priests and court members
surround the Royal Family,
The hymns, the dances, the gifts;
A solemn and splendid ritual.
Do you recall, Pharaoh
the day of glory?

RAMESSES
The day of glory
Nefertari shines bright and luminous.
Wearing the crown of Sothis with a lofty majesty.
The morning star.

Out of love for her the sun rises
I, Ramesses the Great,
Radiant with power,
throw my first ray at the horizon.

The waters burst out,
into a rushing torrent,
and grant life
to the beloved land of Egypt,
gift of the Nile.

Decay and Epilogue
PROMISE OF CENTURIES
(Heaven is the desert)

WIND
In the ancient days,
Ramesses contemplated these stars.

They say the heavenly bodies guide men.
It could be so.
I know, that the vault of heaven is the desert.
The mirror of time
that reflects the constellations of the sand.

Deeds of men, reminders of glory,
submerge in the shade of centuries.

Memory, like the night,
is but a promise.

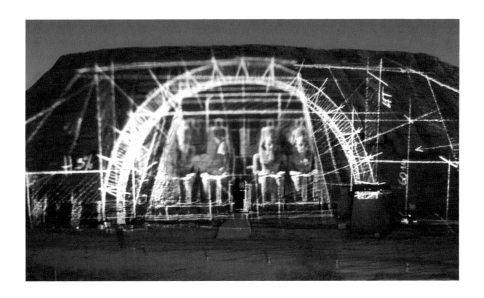

The Creators of the Sound and Light Show at Abu Simbel
Script: Dr. Gamal Mokhtar; Dr. Gaballah Ali Gaballah; Dr. Zahi Hawass.
Scenario: Rafael Rodri. Music: Lioppis Pep. Artistic direction: Eric Teunis.
Graphic design: Javier Garcia.

Suggestions for Further Reading

The British Museum Book of Ancient Egypt, edited by A. J. Spencer.
British Museum Press, The American University in Cairo Press, 2007.

The Complete Gods and Goddesses of Ancient Egypt, Richard H.
Wilkinson. Thames & Hudson, The American University in Cairo
Press, 2005.

*The Complete Pharaohs: The Reign-by-Reign Record of the Rulers
and Dynasties of Ancient Egypt*, Peter A. Clayton. The American
University in Cairo Press, 2006.

The Complete Temples of Ancient Egypt, Richard H. Wilkinson. The
American University in Cairo Press, 2005.

A History of Egypt: From Earliest Times to the Present, Jason
Thompson. Haus Publishing, The American University in Cairo Press,
2008.

*The Mysteries of Abu Simbel: Ramesses II and the Temples of the Rising
Sun*, Zahi Hawass. The American University in Cairo Press, 2000.

Pharaonic Civilization: History and Treasures of Ancient Egypt,
Giorgio Ferrero. The American University in Cairo Press, 2008.

The Queens of Ancient Egypt, Rosanna Pirelli. The American University
in Cairo Press, 2008.

Ramesses the Great, T. G. H. James. The American University in Cairo
Press, 2002.